My Digital Art

Gemstone Art, By Vijay Simhadri:

Here in the Art Catalogue, I have digital paintings of realistic imagery of gemstones. For instance, there are digital paintings of the following:

* Cut Gemstone Diamond Art.

* Gold & Silver Art.

* Emerald Gemstone Art.

* Alexandrite Gemstone Art.

* Ruby Gemstone Art.

Cut Diamond Sphere & Pure Gold Pyramid:

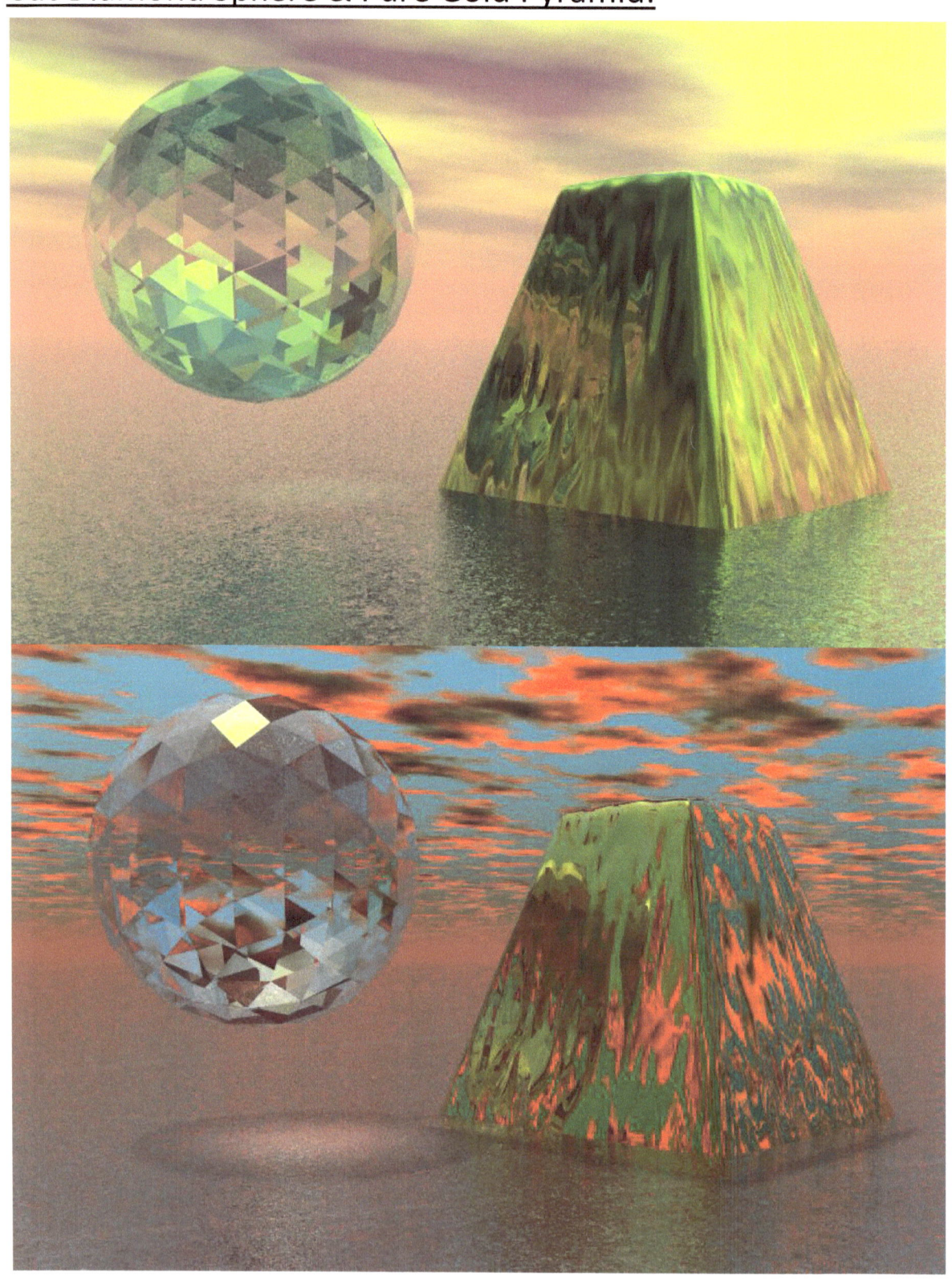

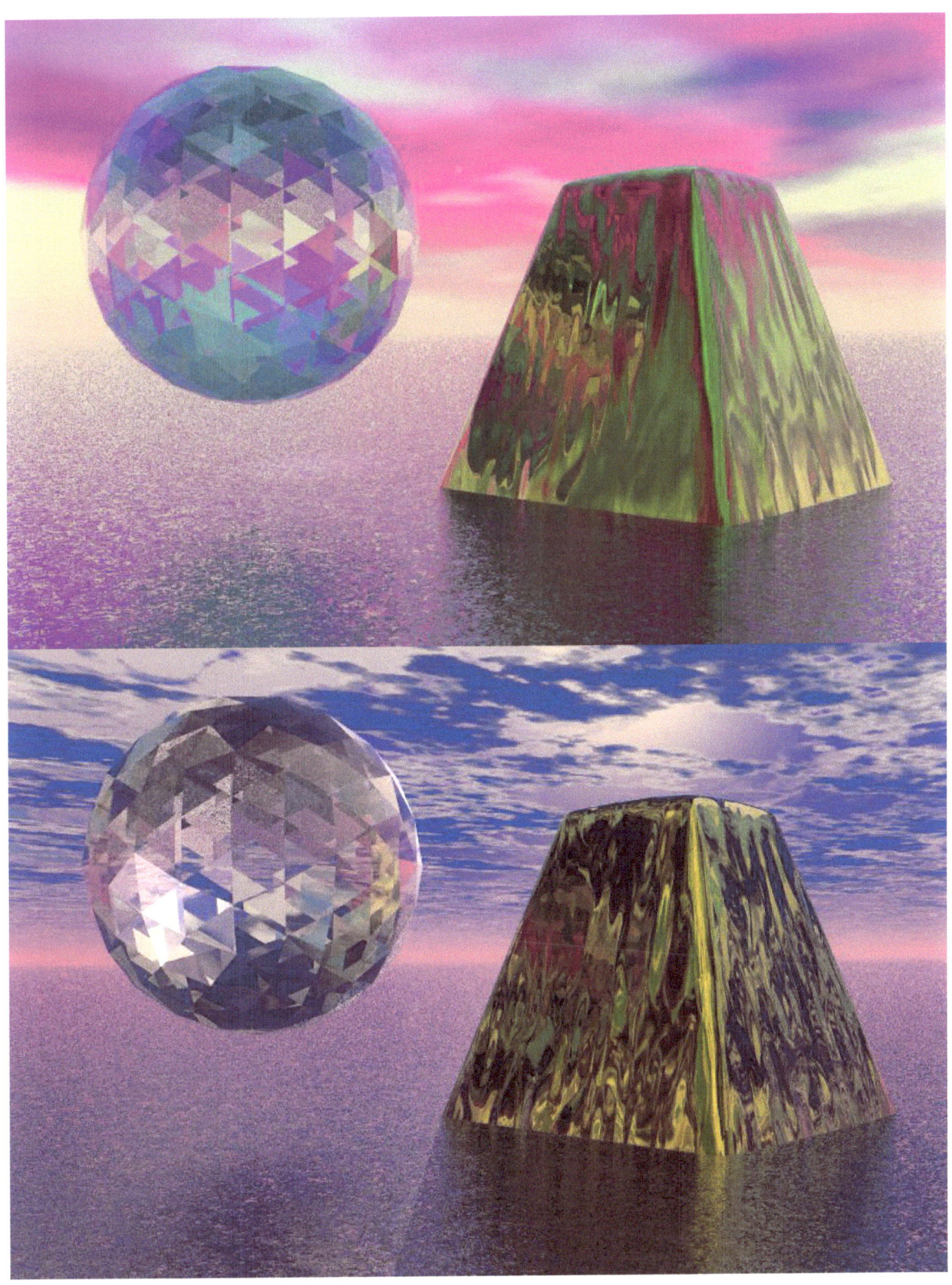

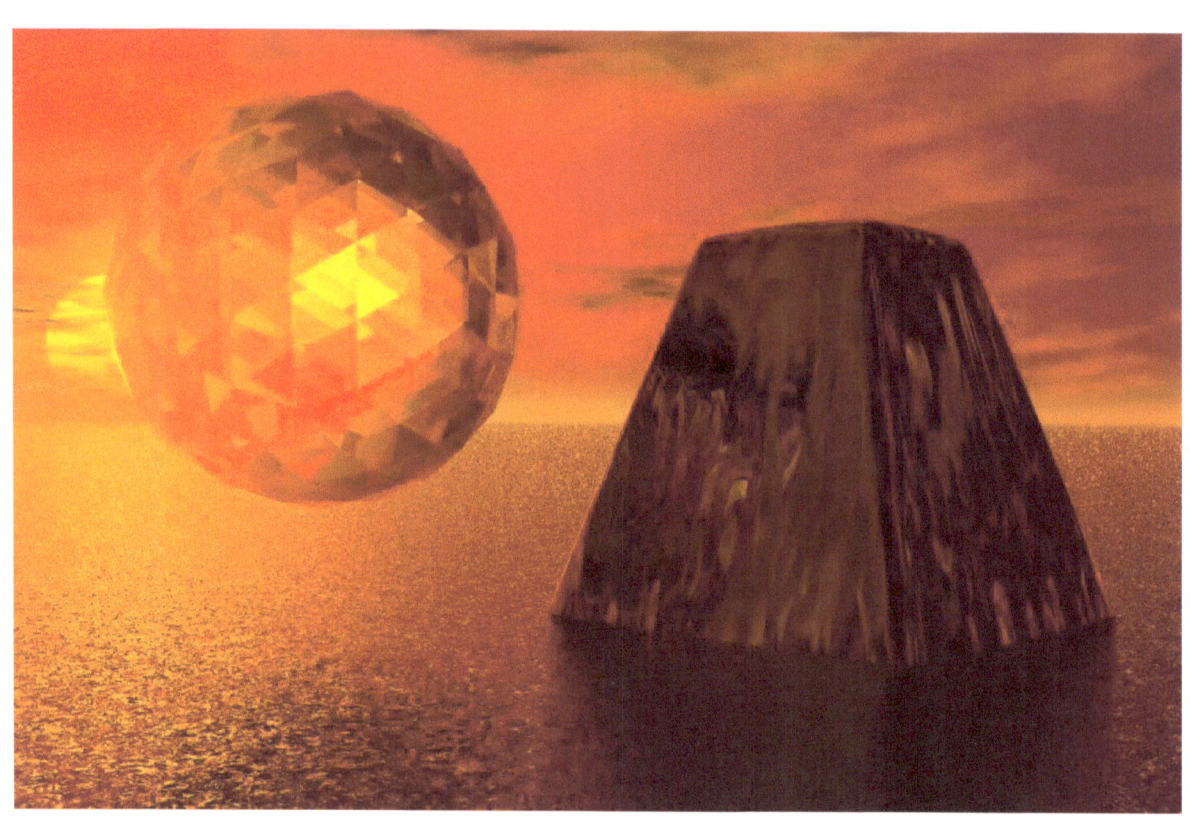

Rotated Diamond Cube:

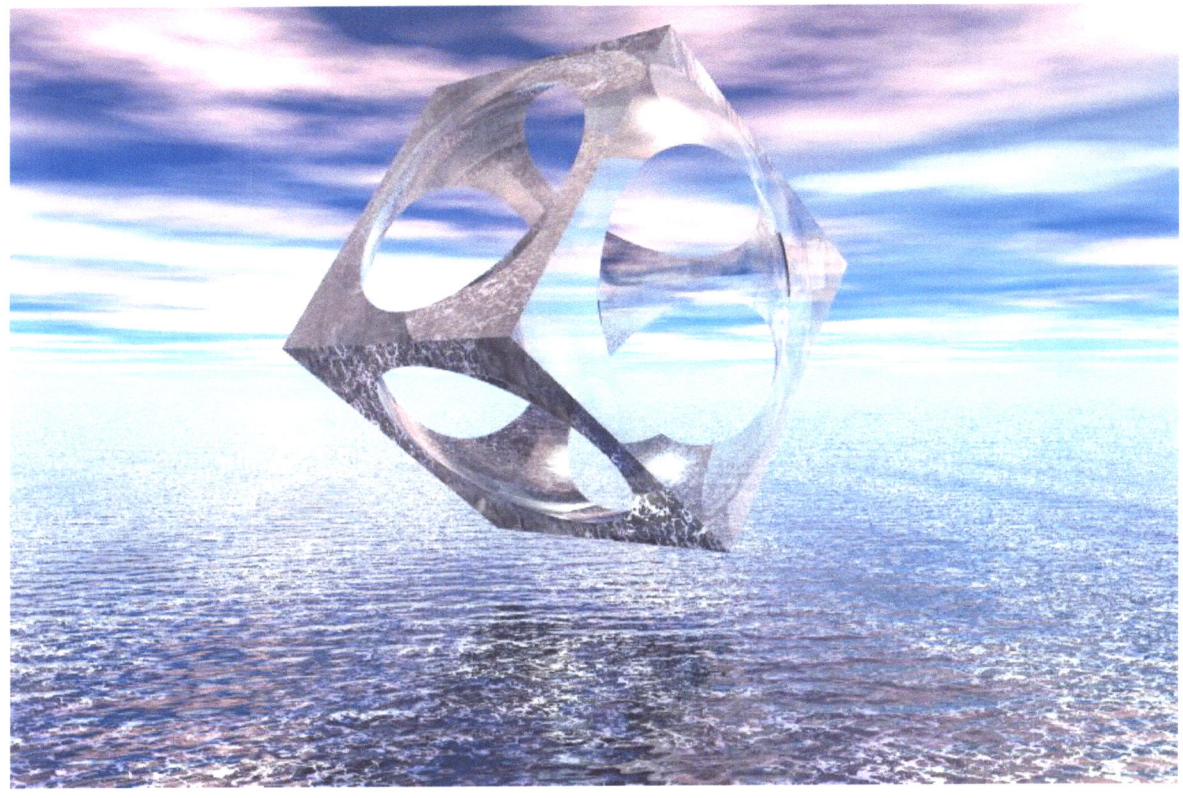

Diamond Octahedrons:

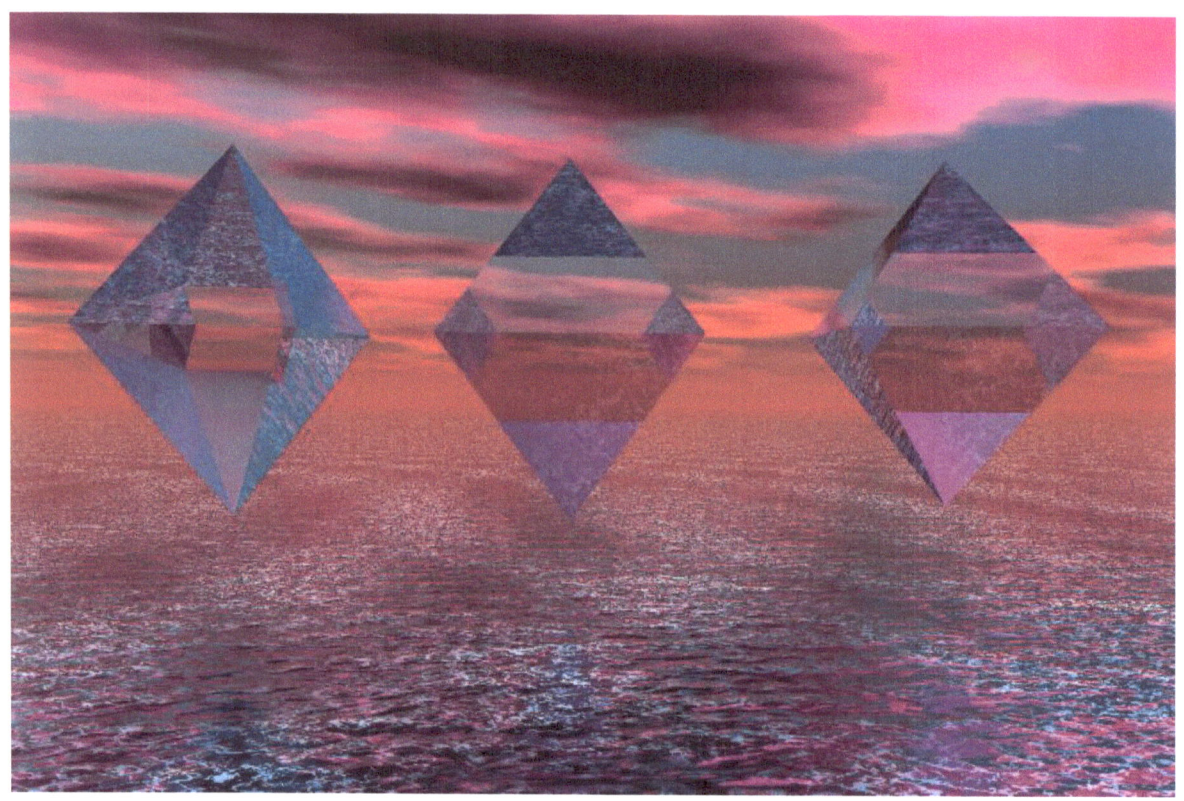

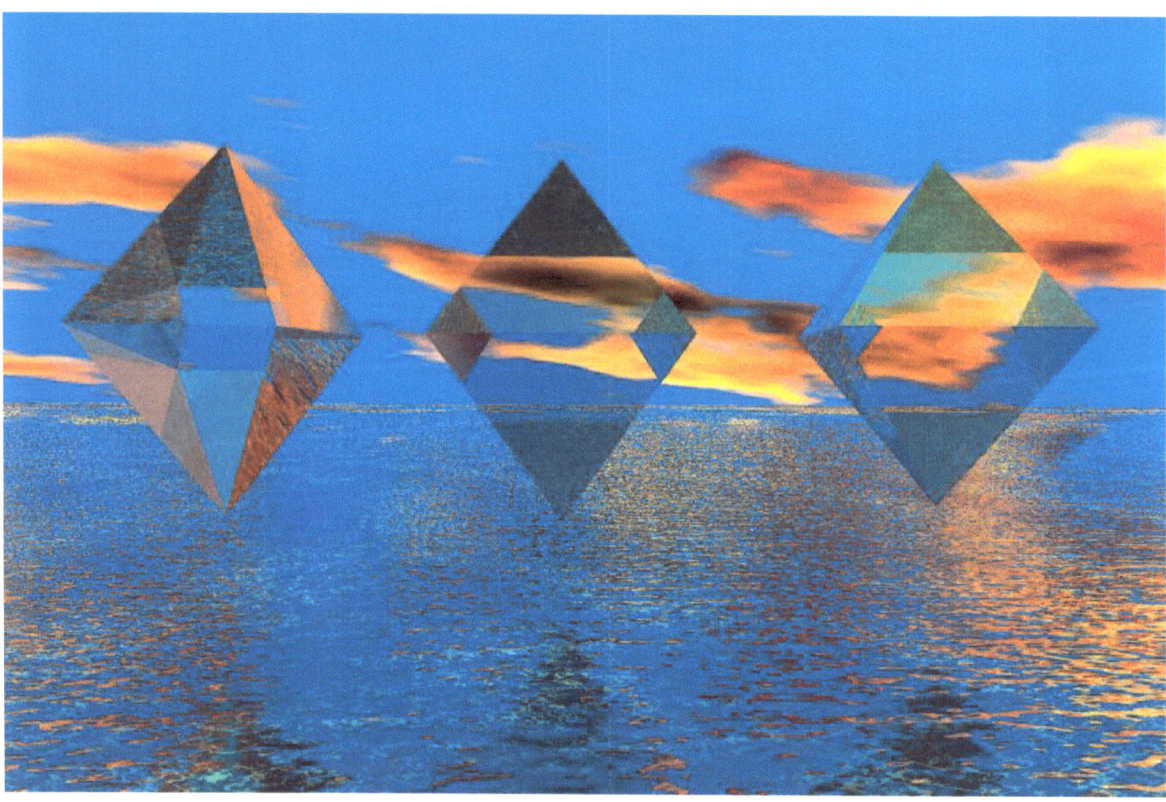

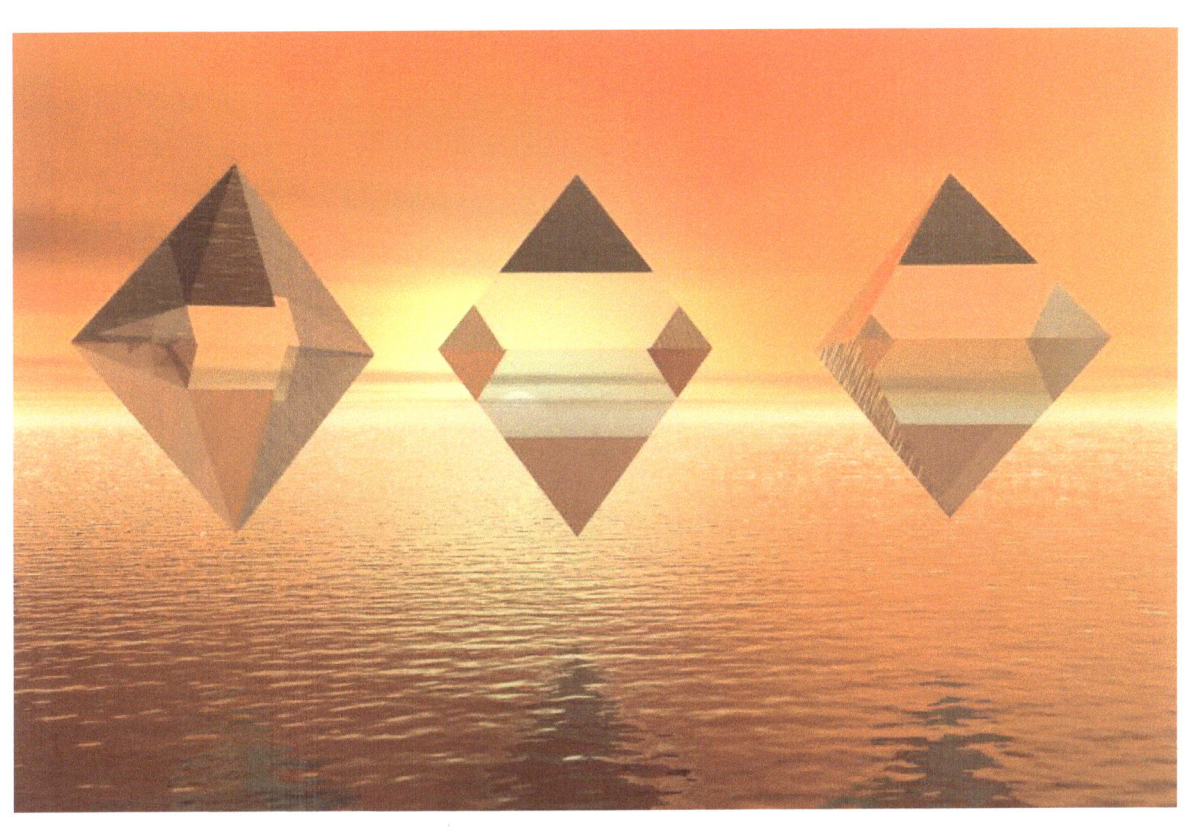
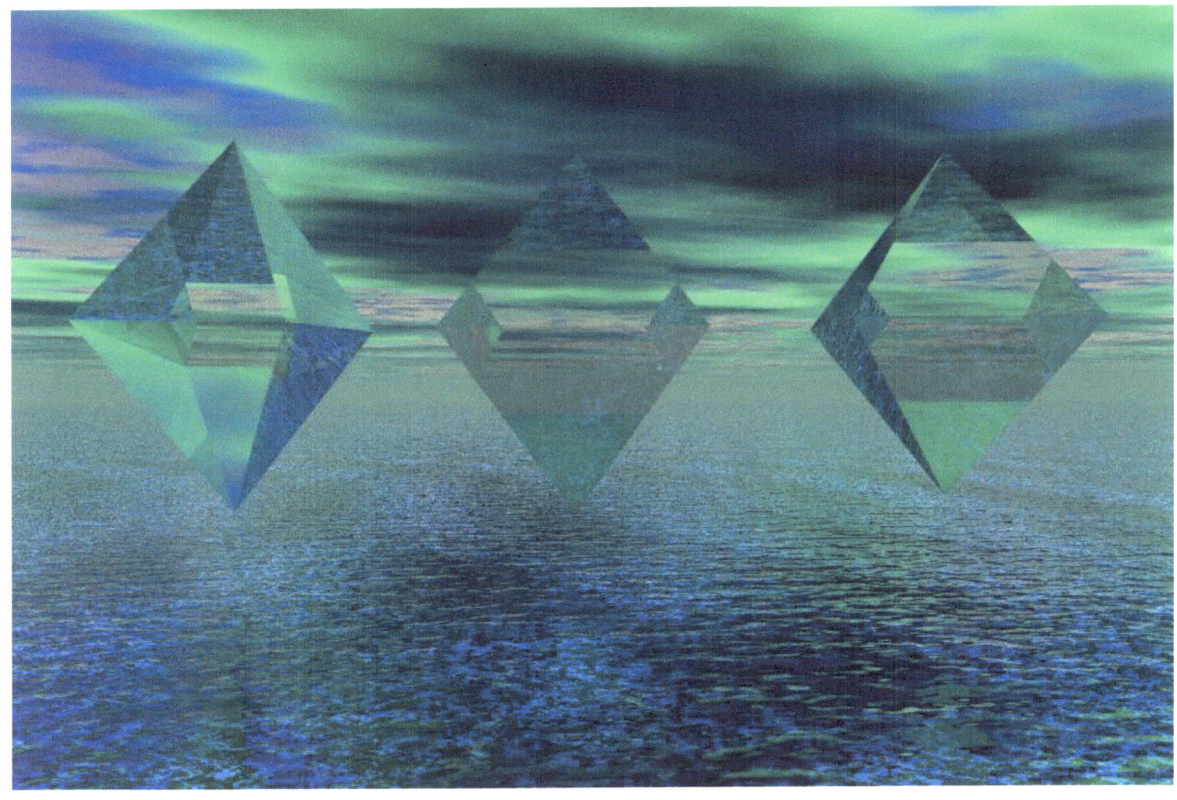

Diamond Dodecahedron & Emerald Polygon:

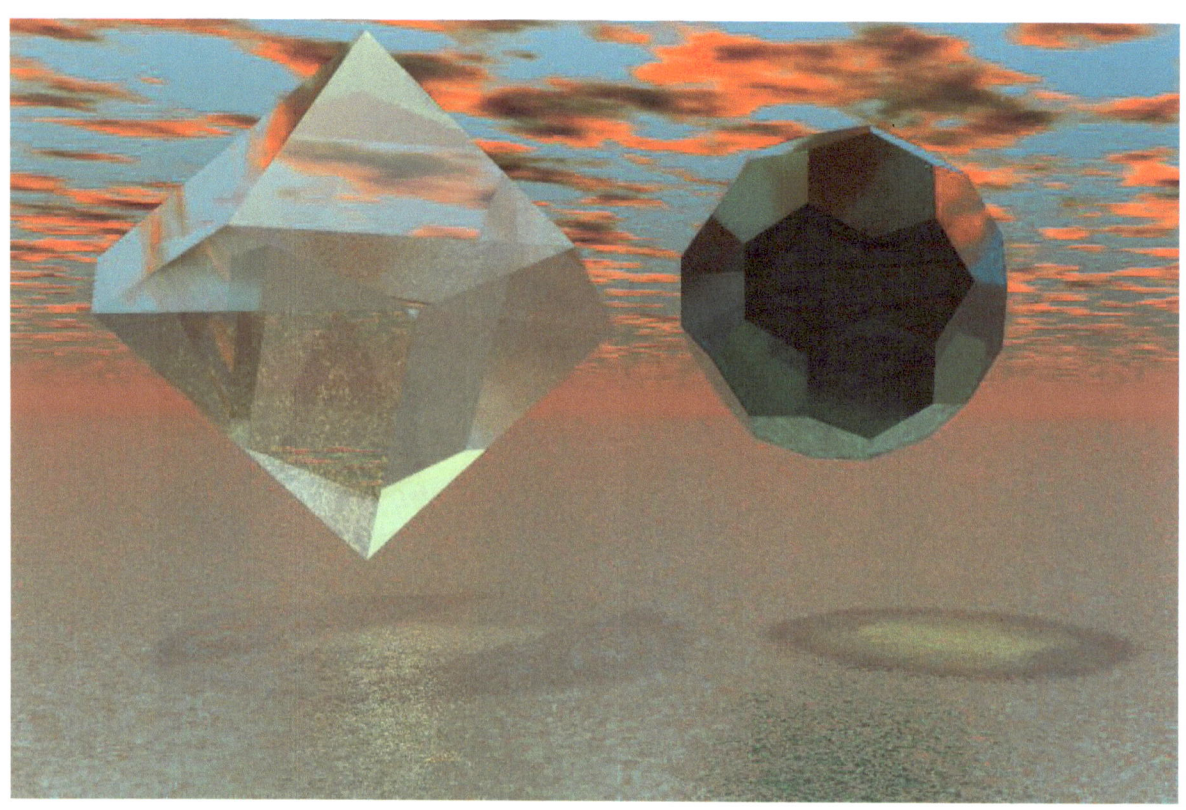

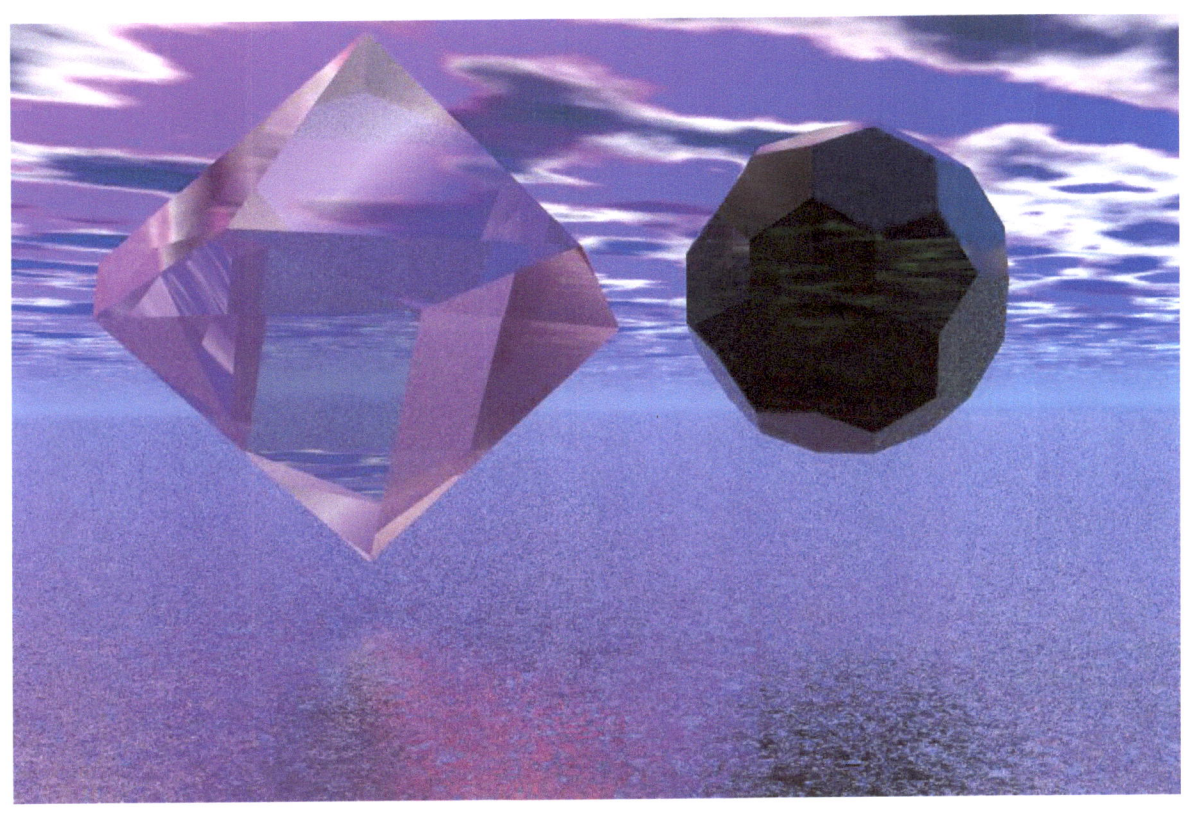

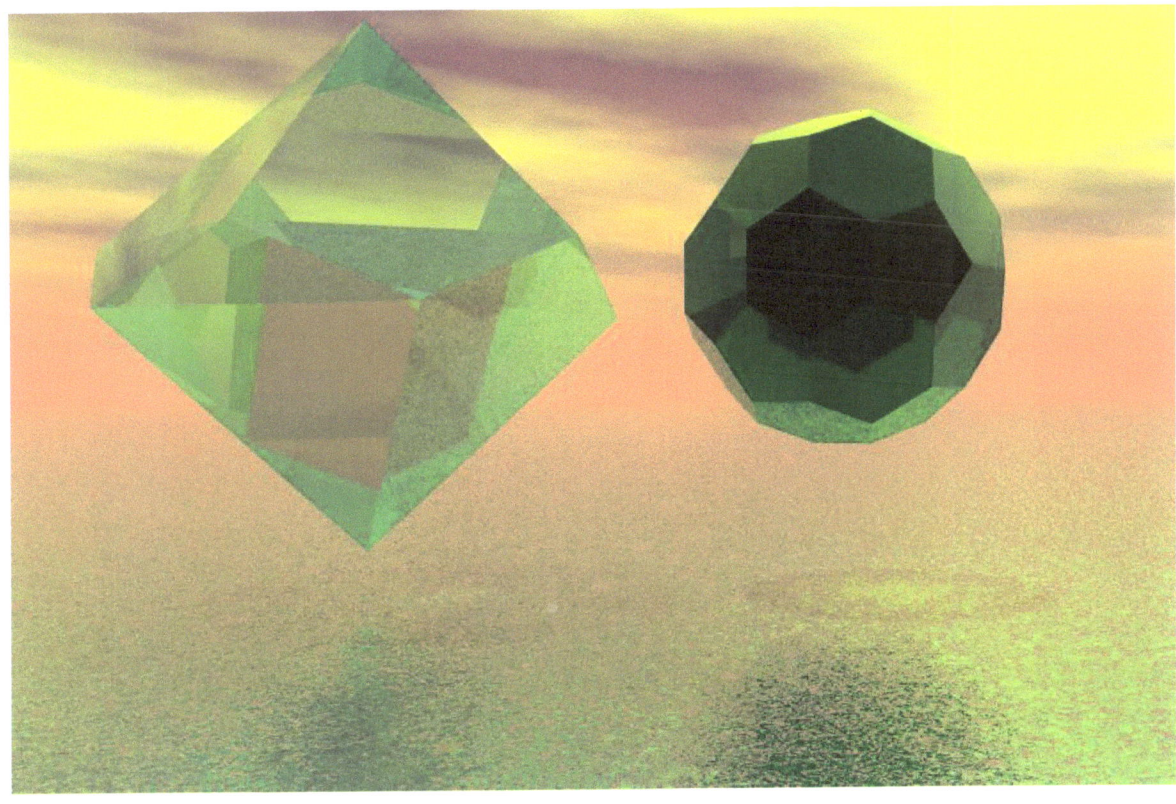

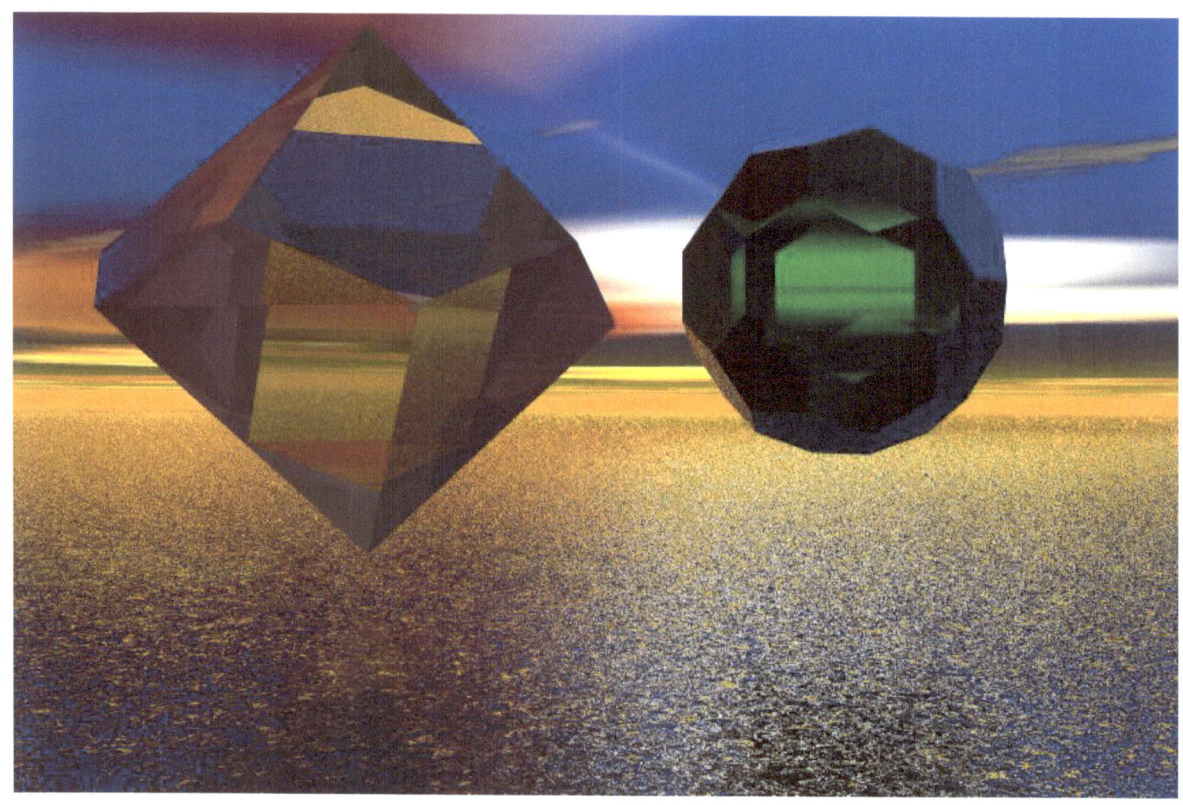

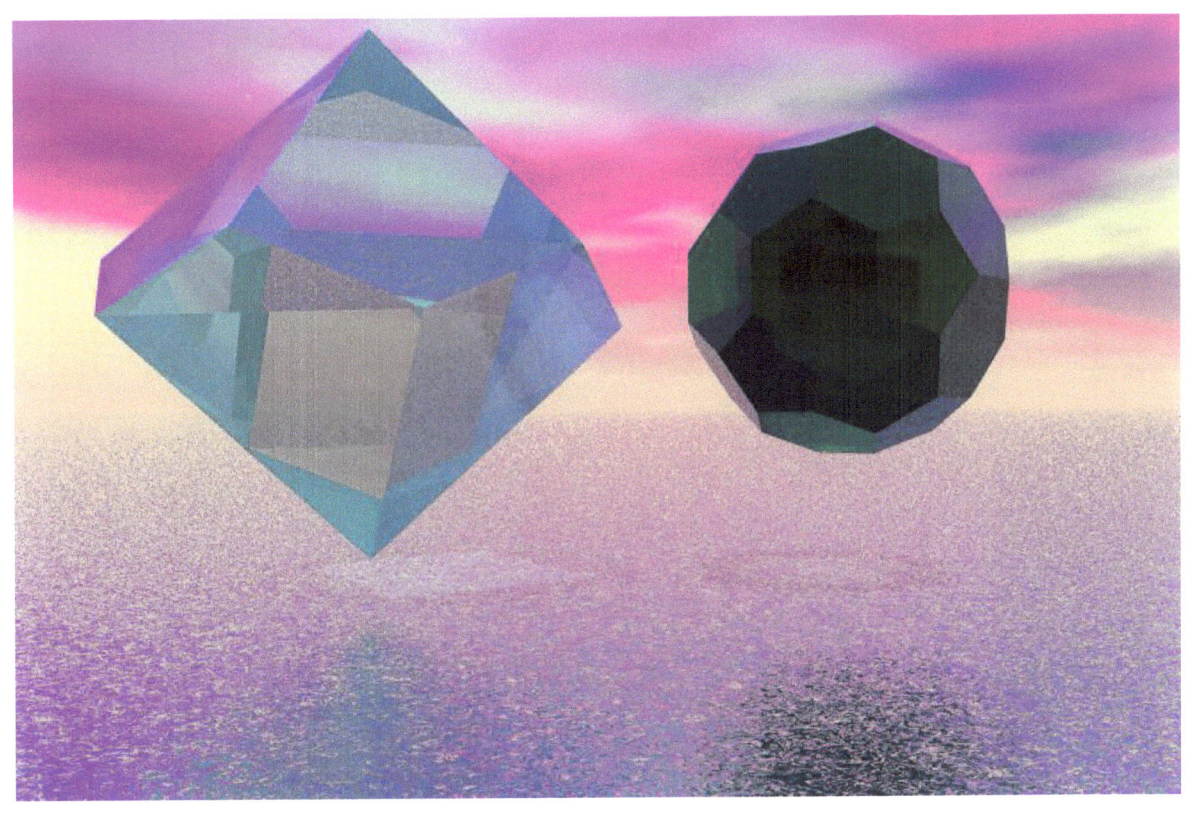

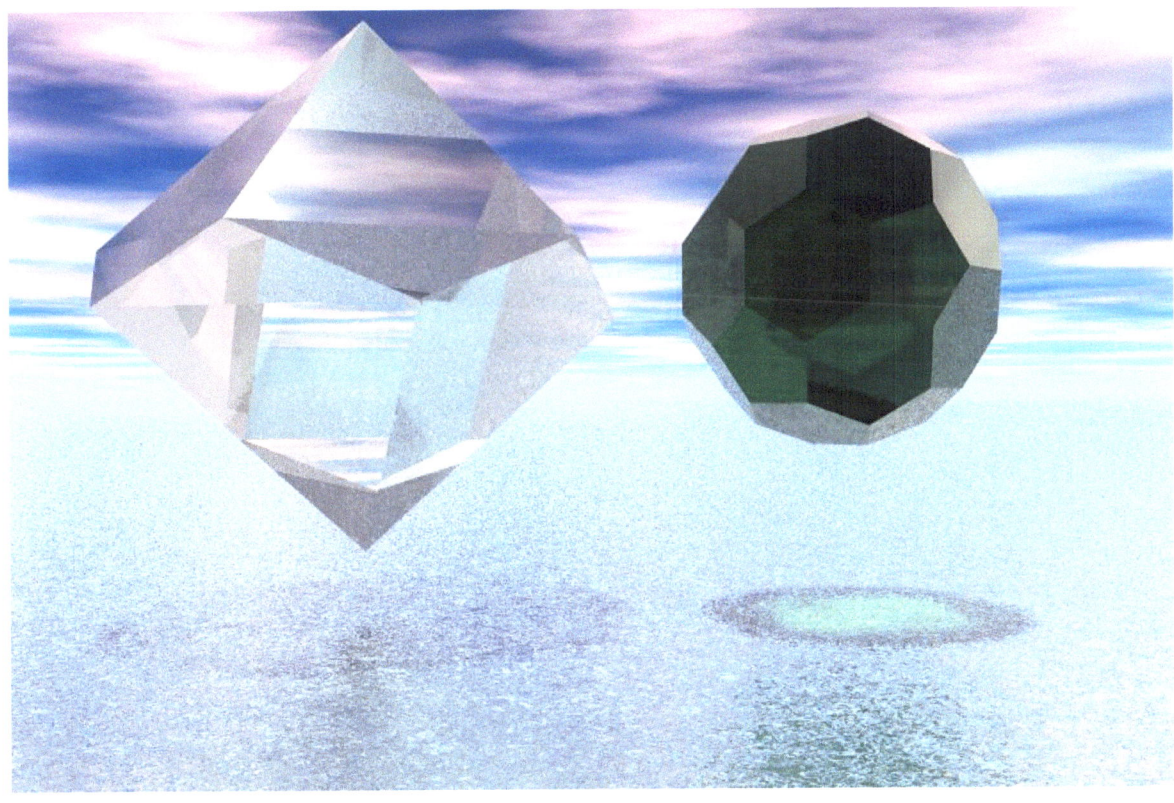

Diamond Pyramid, Alexandrite (Purple) Sphere, Emerald Cylinder, & Citrine (Orange) Cylinder.

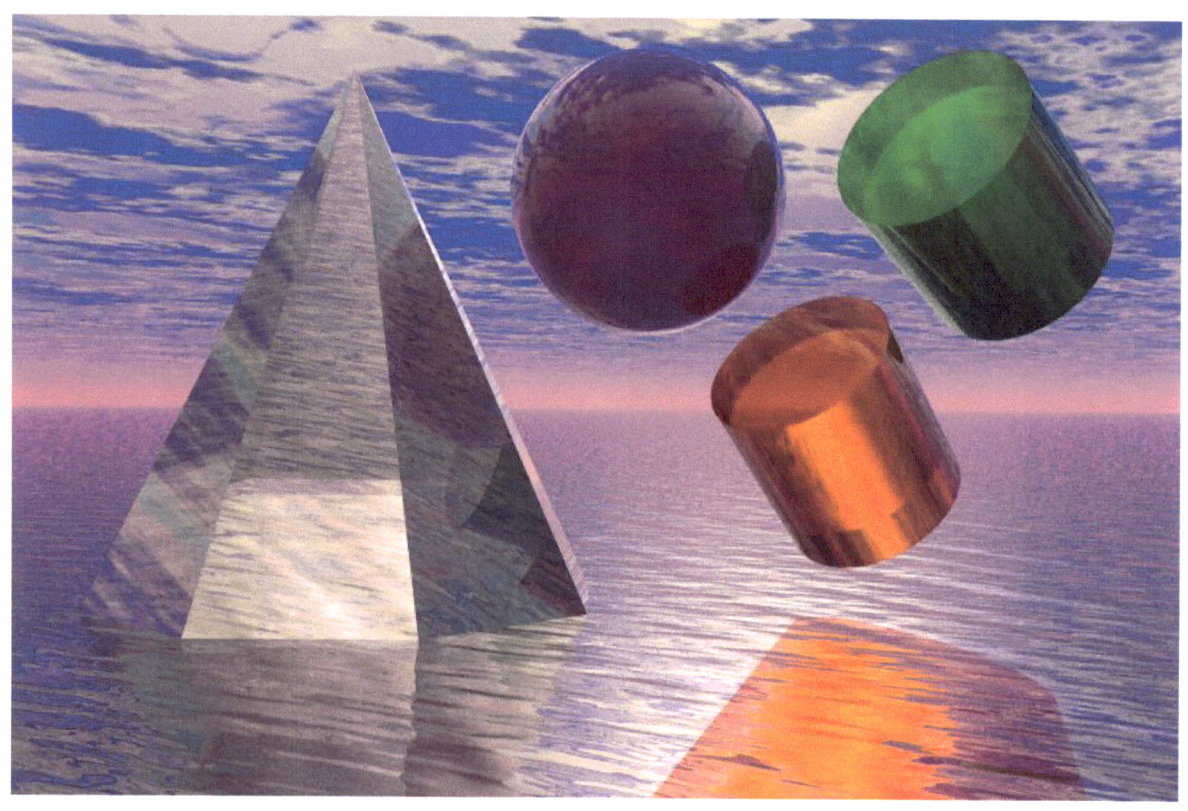

5 -sided Diamond Pyramid & Cabochon Emerald Sphere:

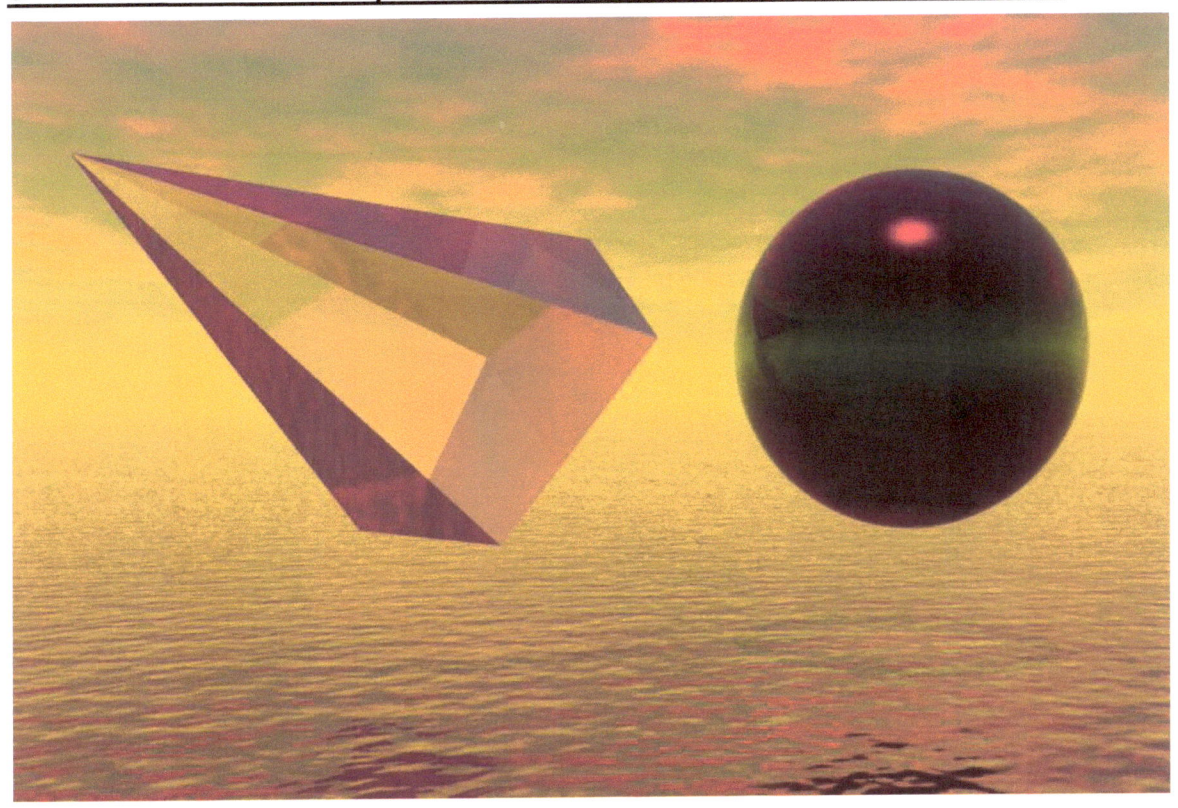

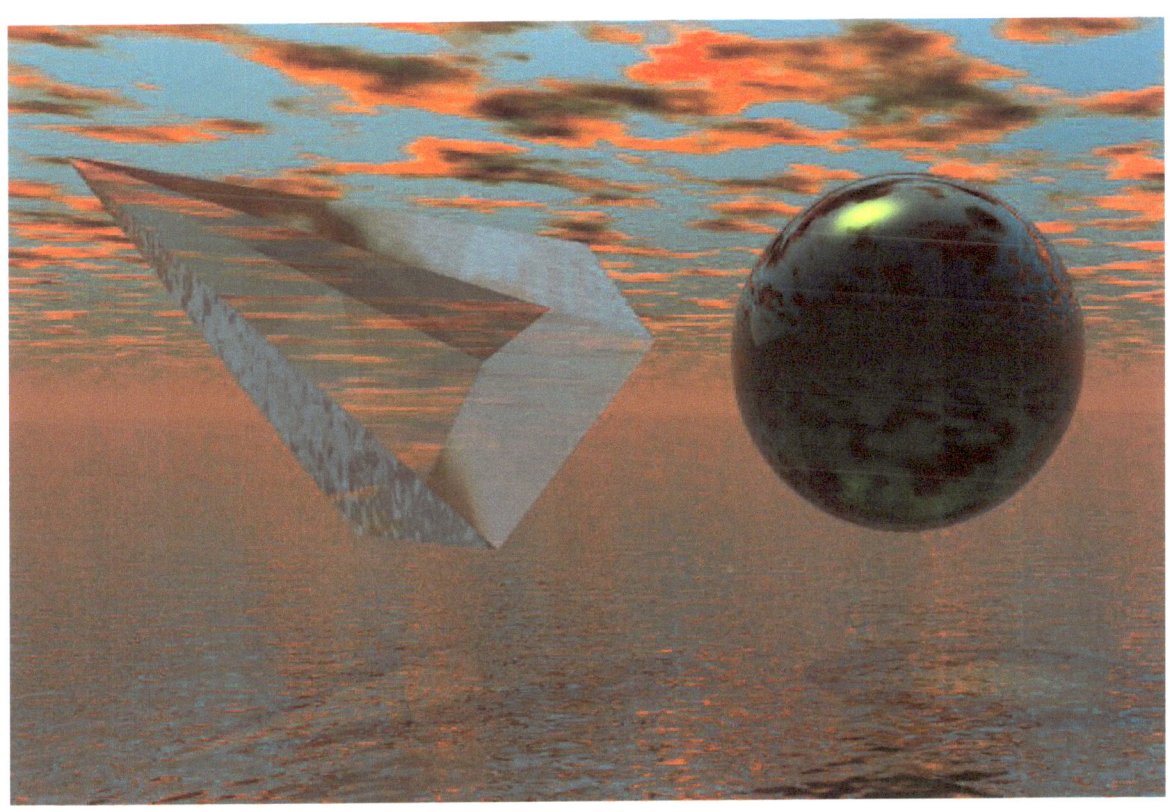

Gold, Silver, & Diamond Art:

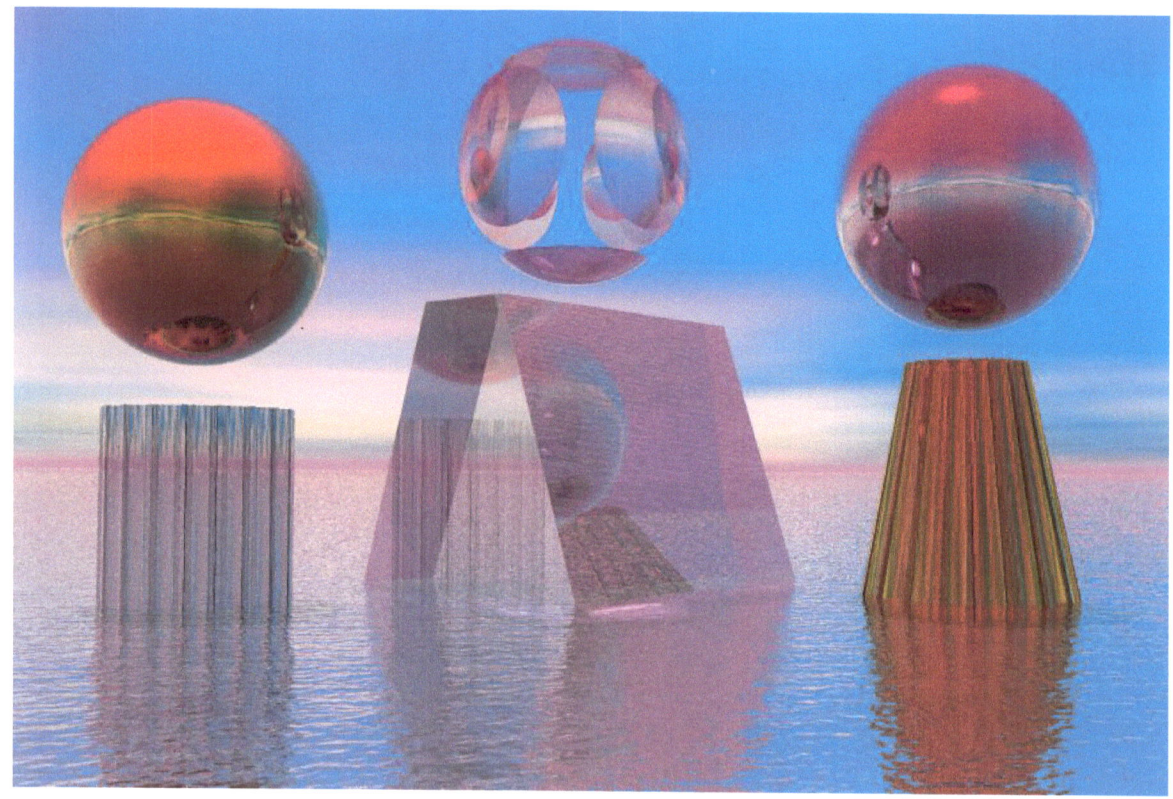

Ruby Sphere, Gold Striated Pyramid & Emerald Sphere:

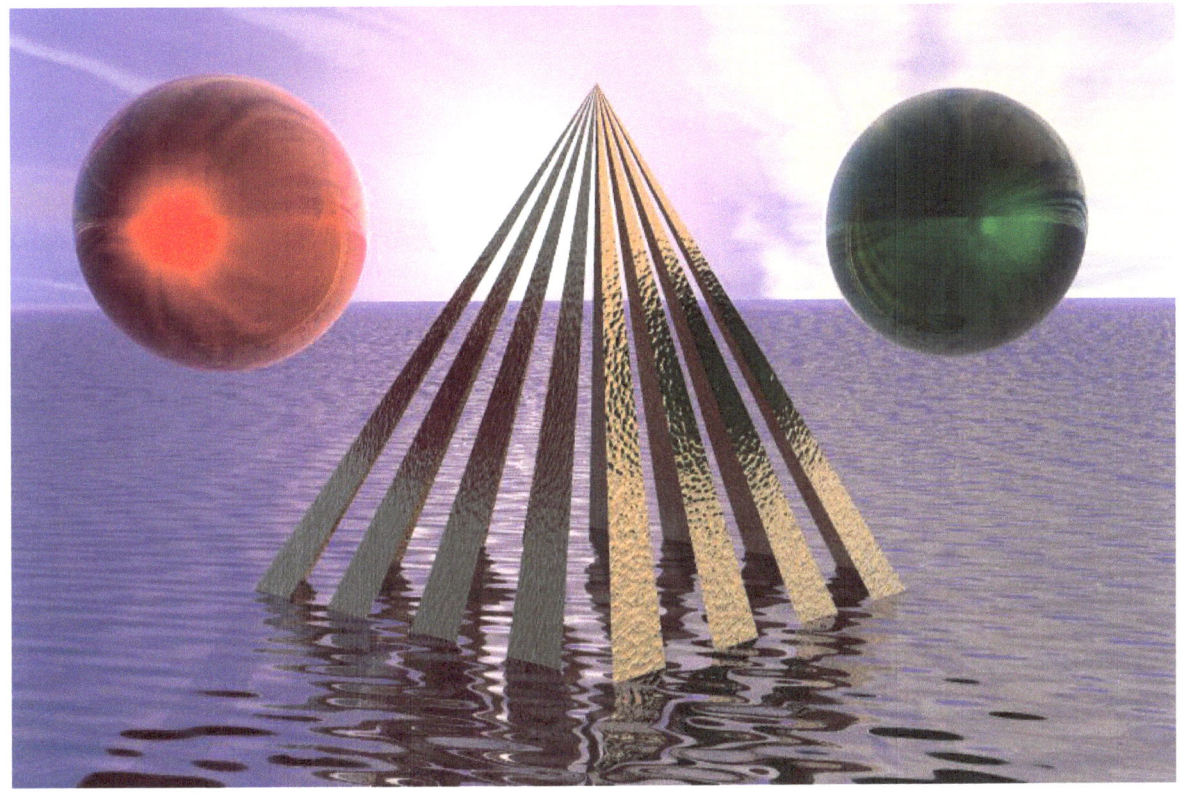

Pure Gold Objects above Landscaping:

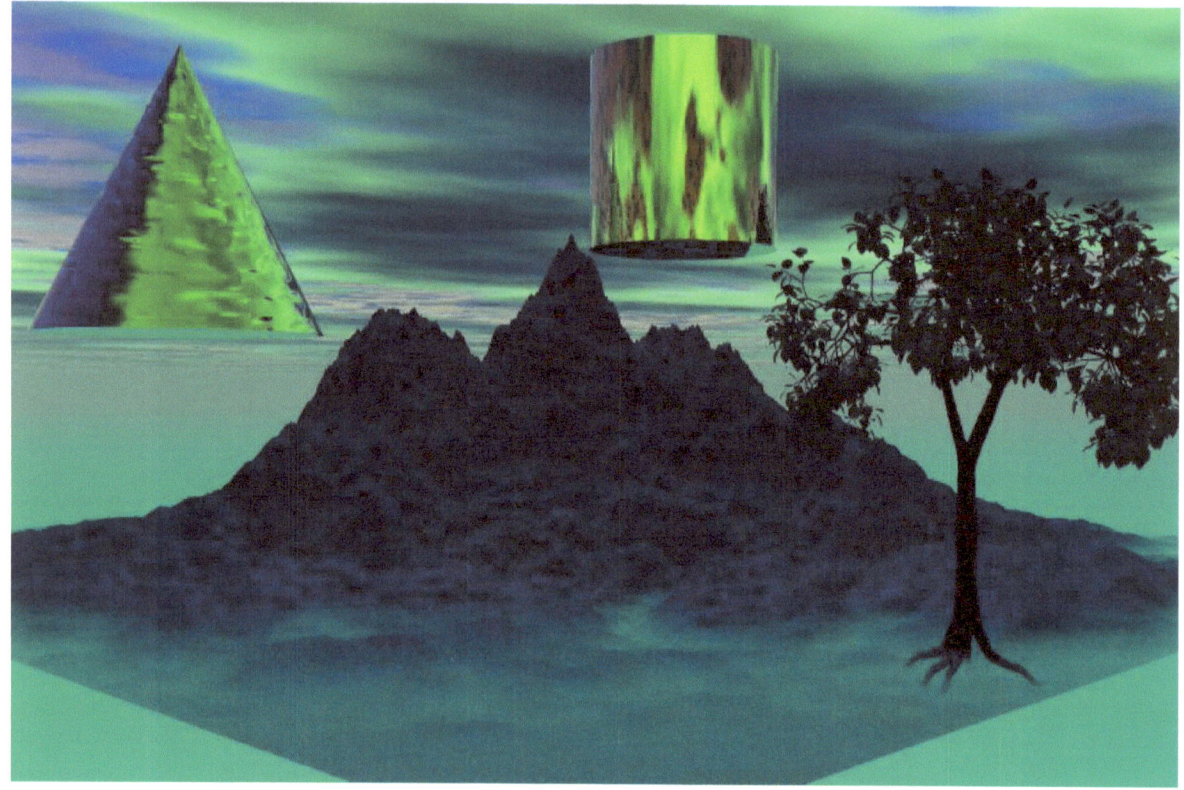

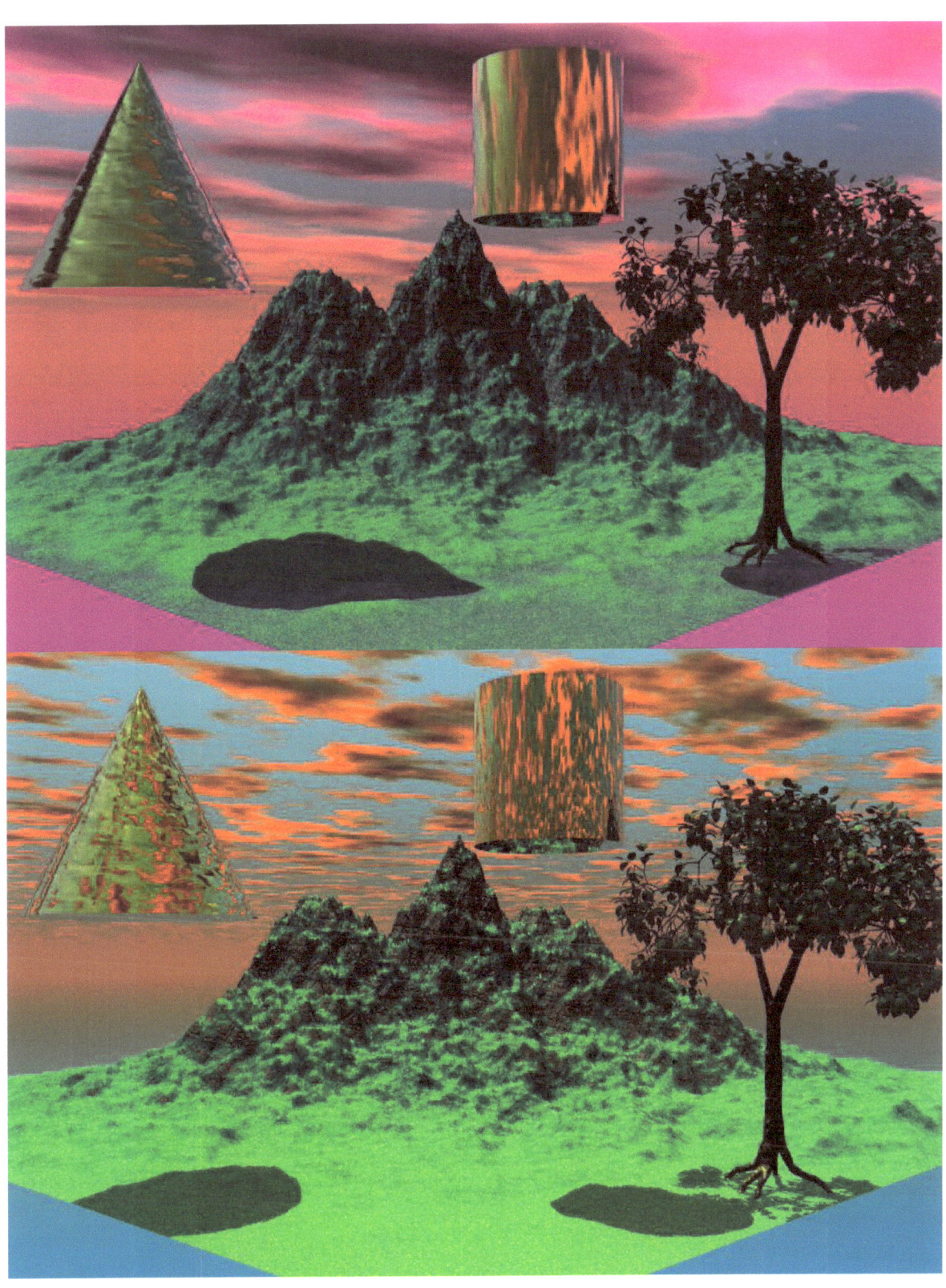

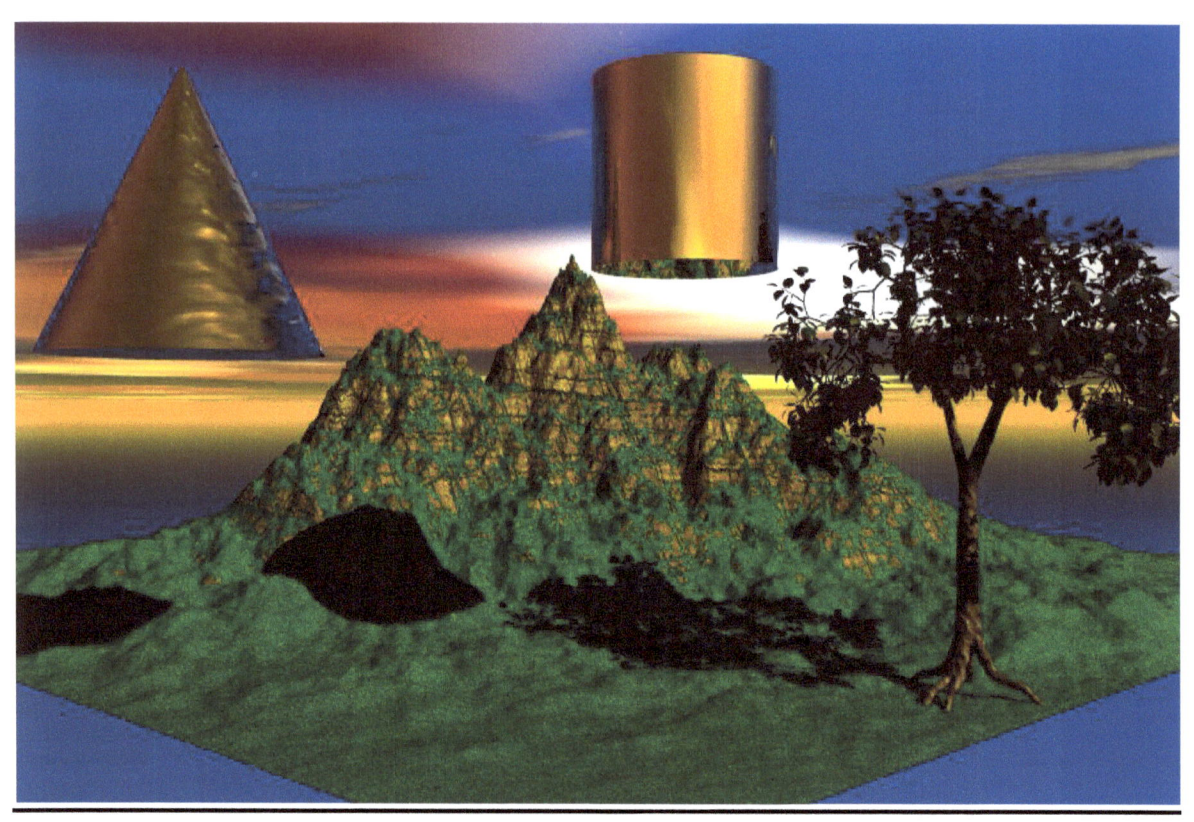

Silver, Gold Pyramid & Diamond Sculpture:

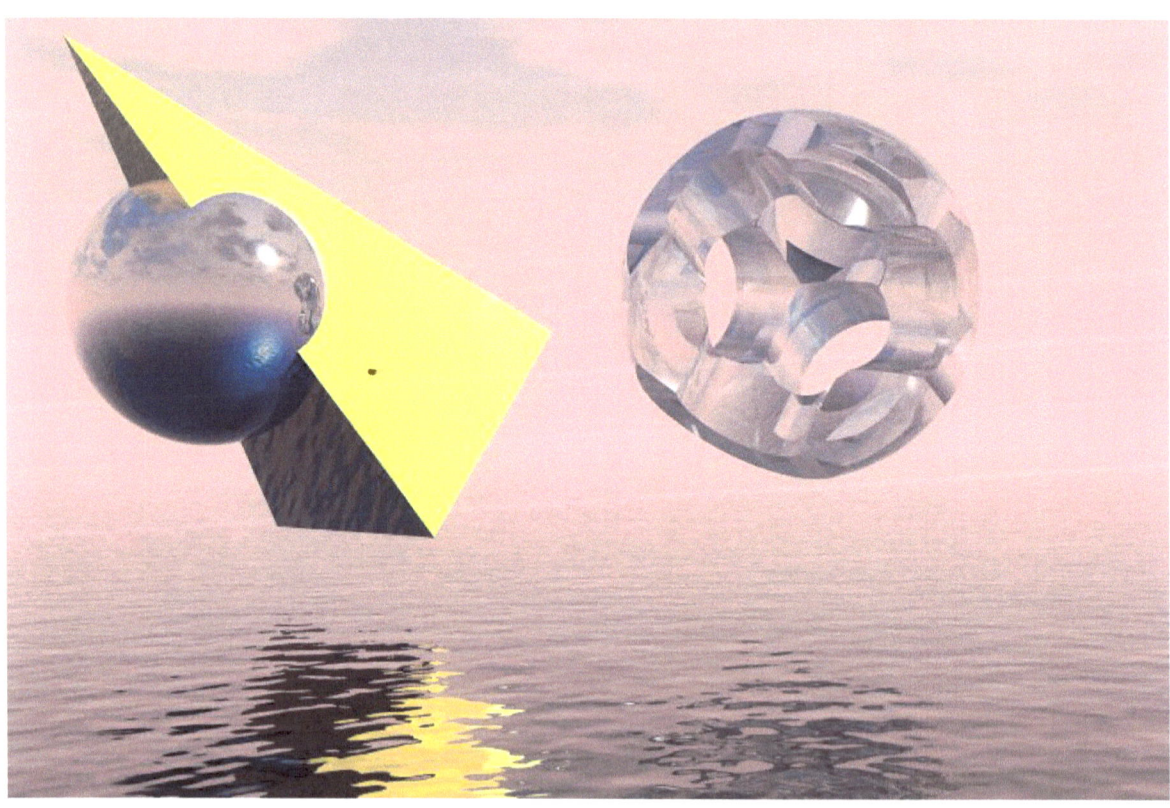

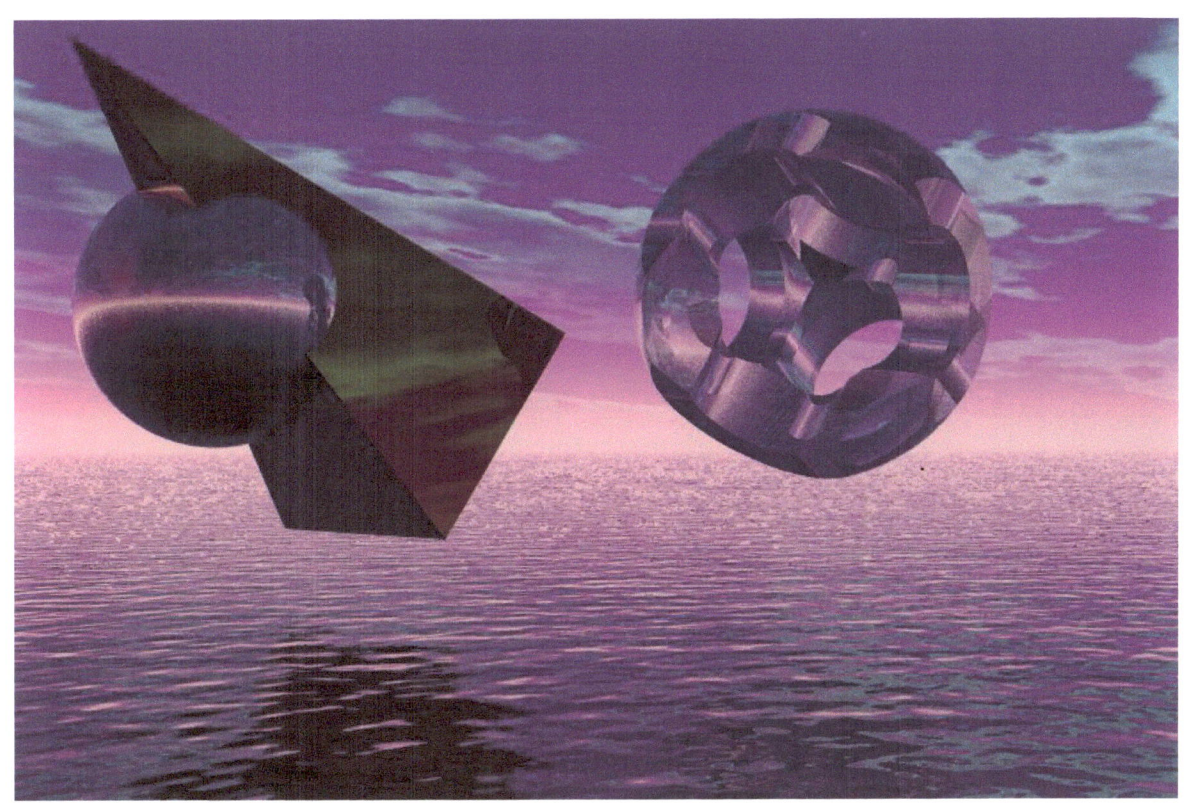

Silver Sphere, Silver Cone & Gold Sphere.

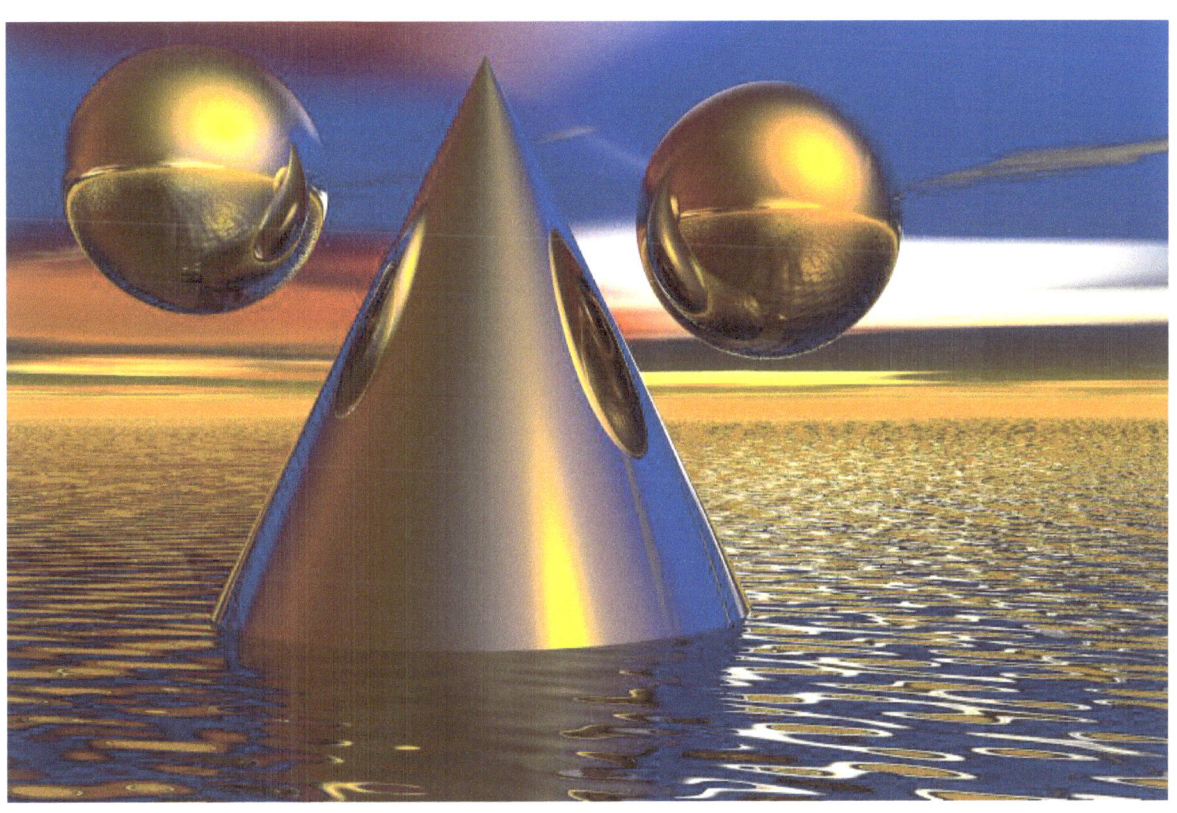

Diamond Cylinder, Gold Sphere & Silver Cube.

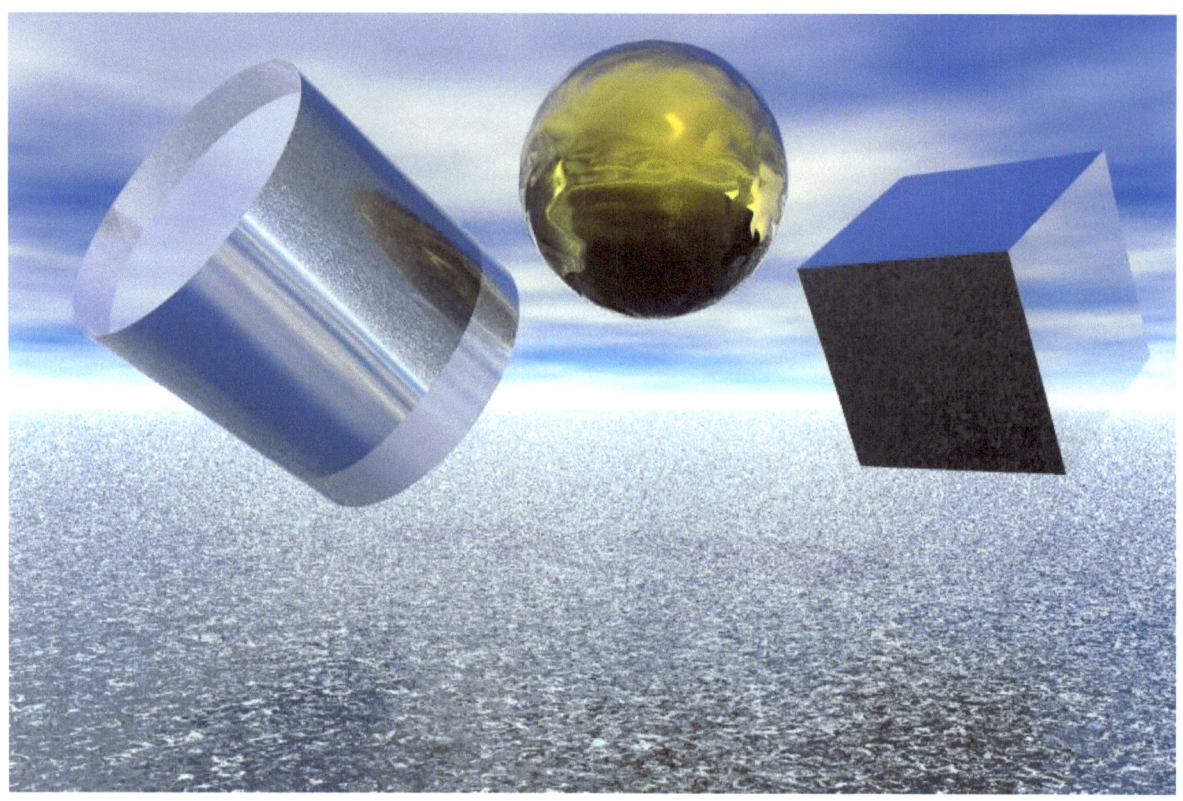

Diamond Polygon & Pedestal:

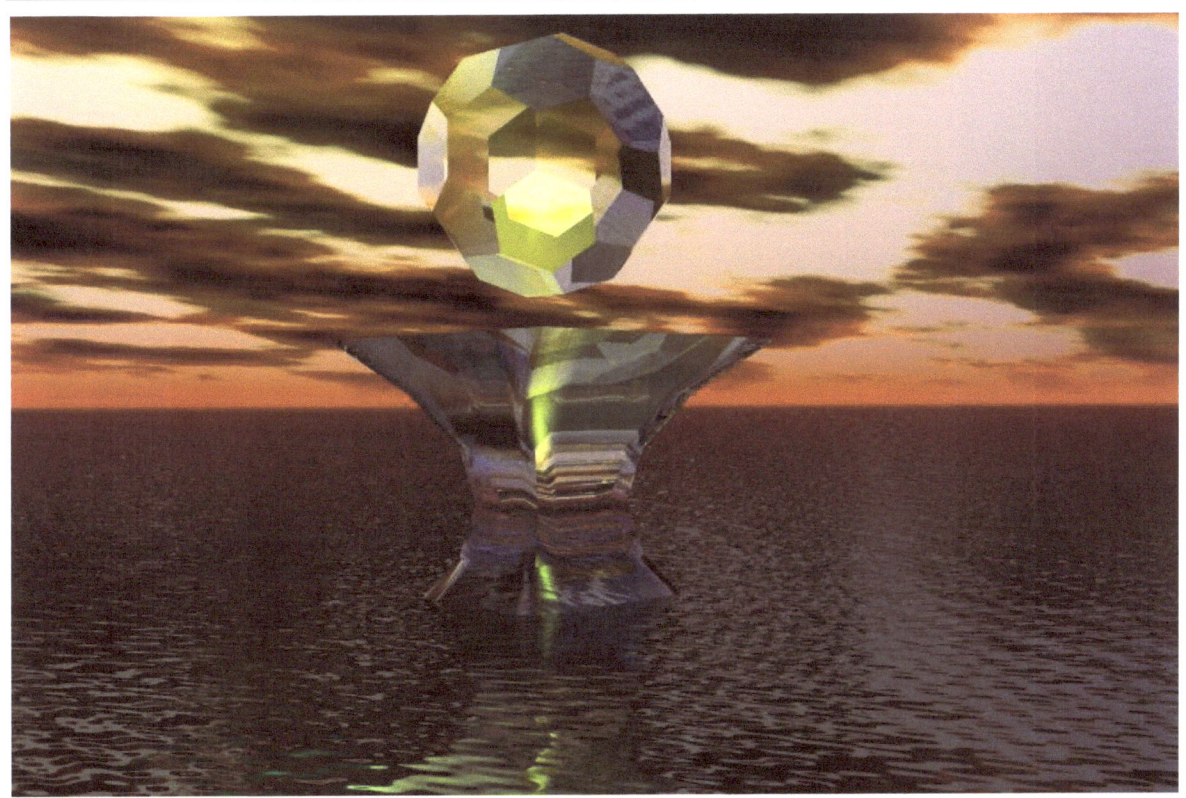

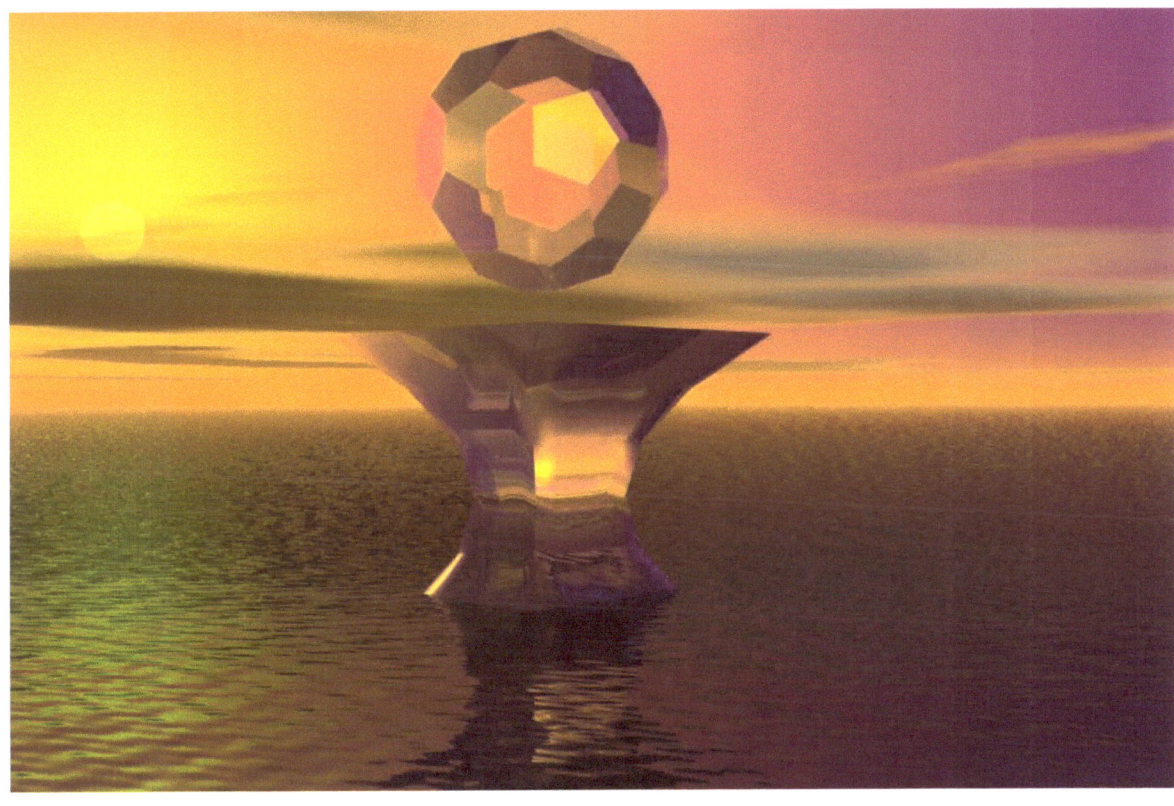

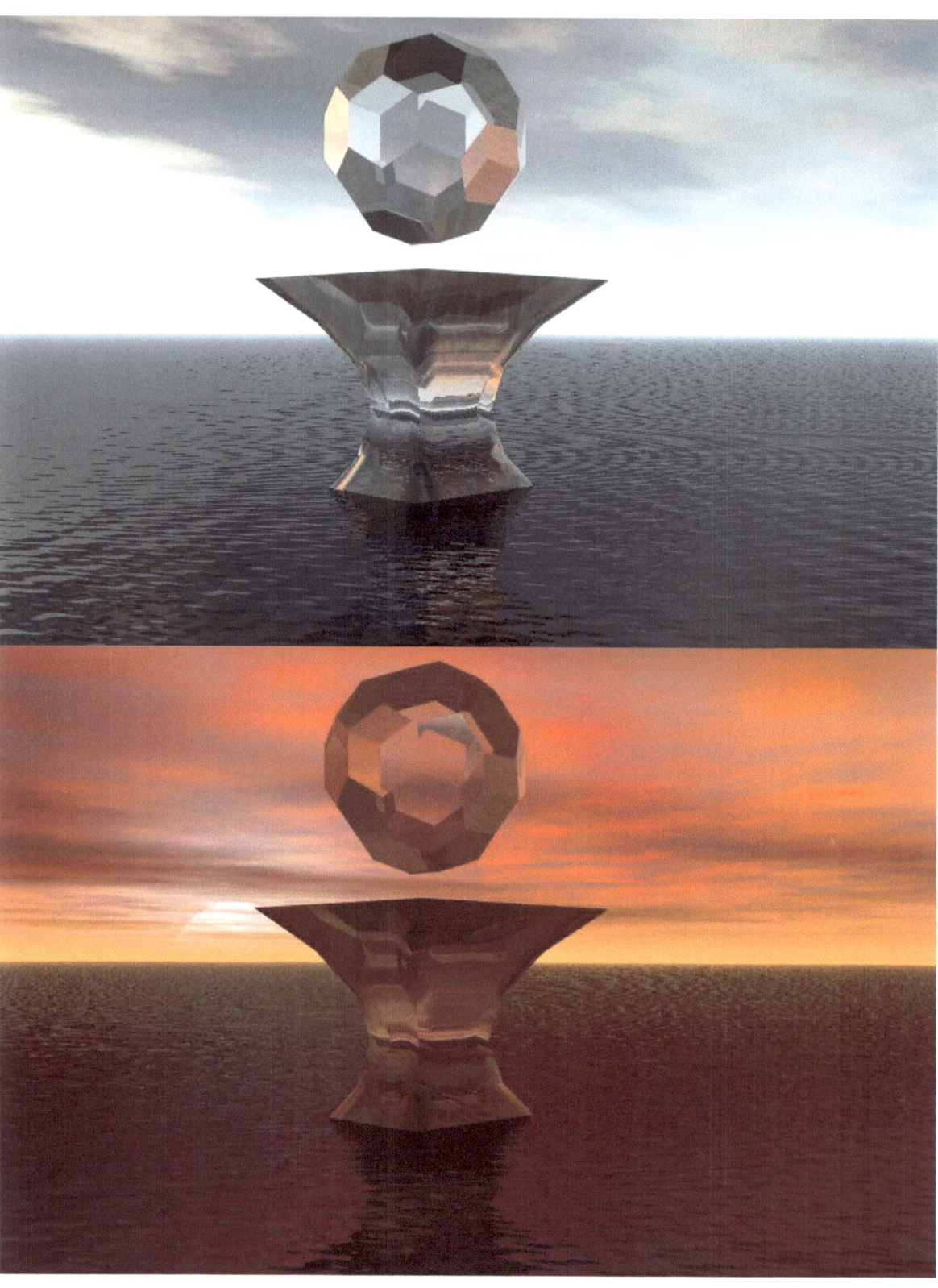

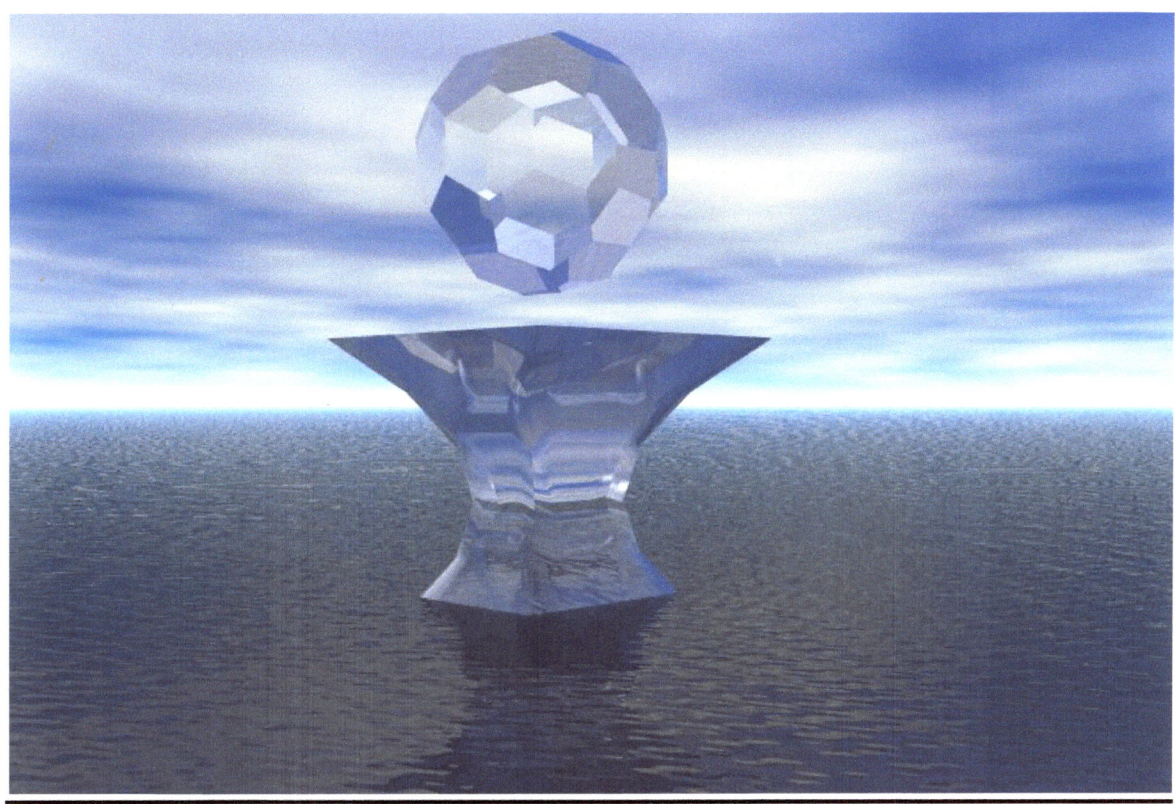
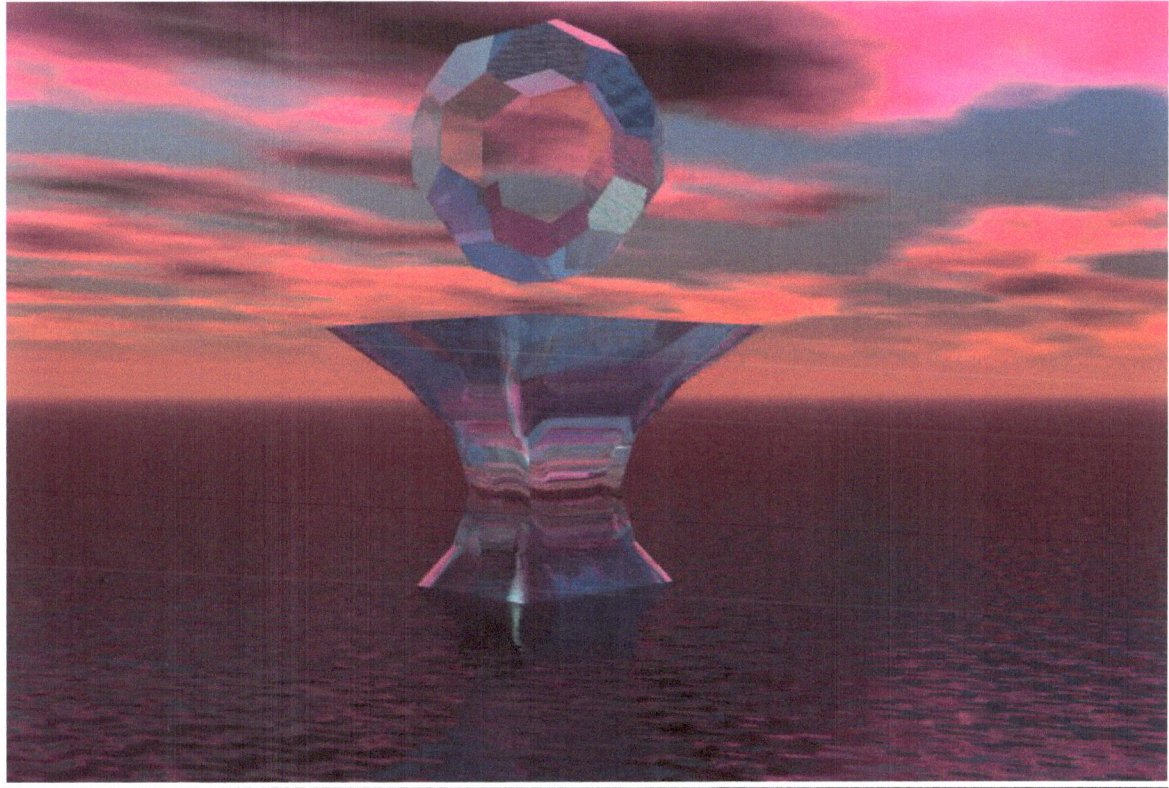

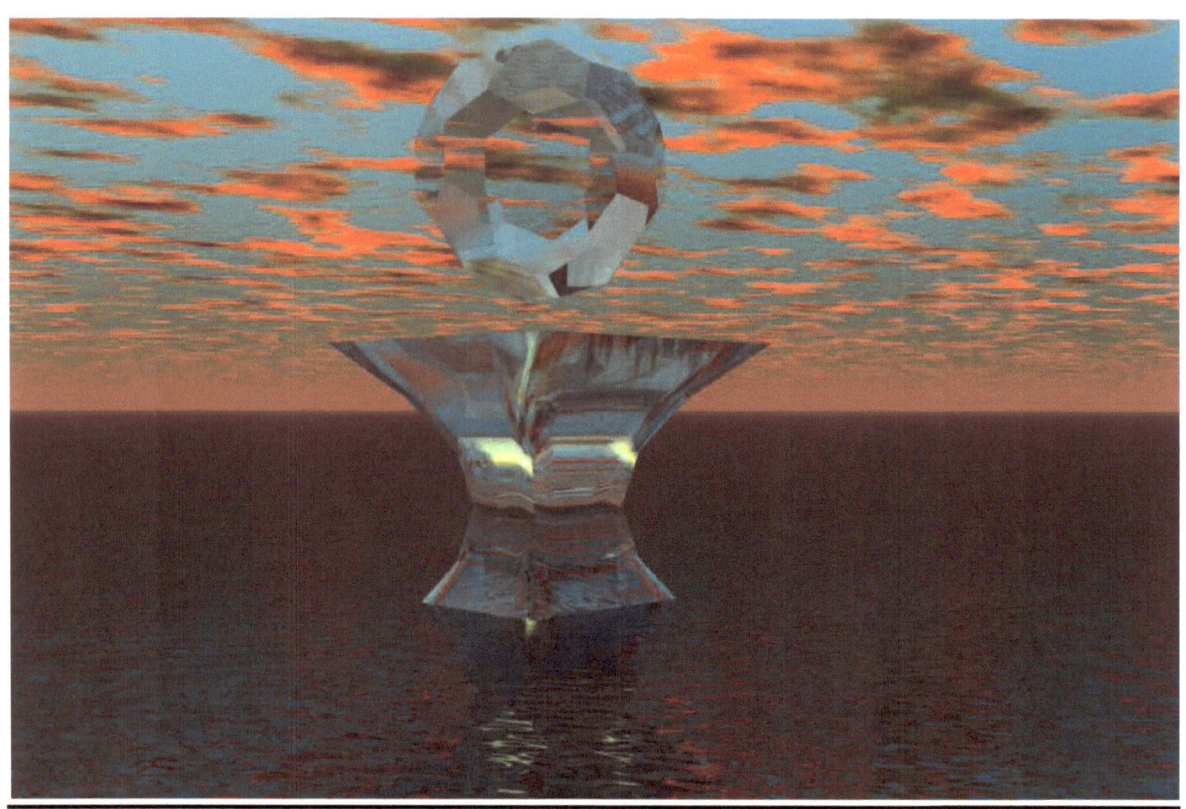
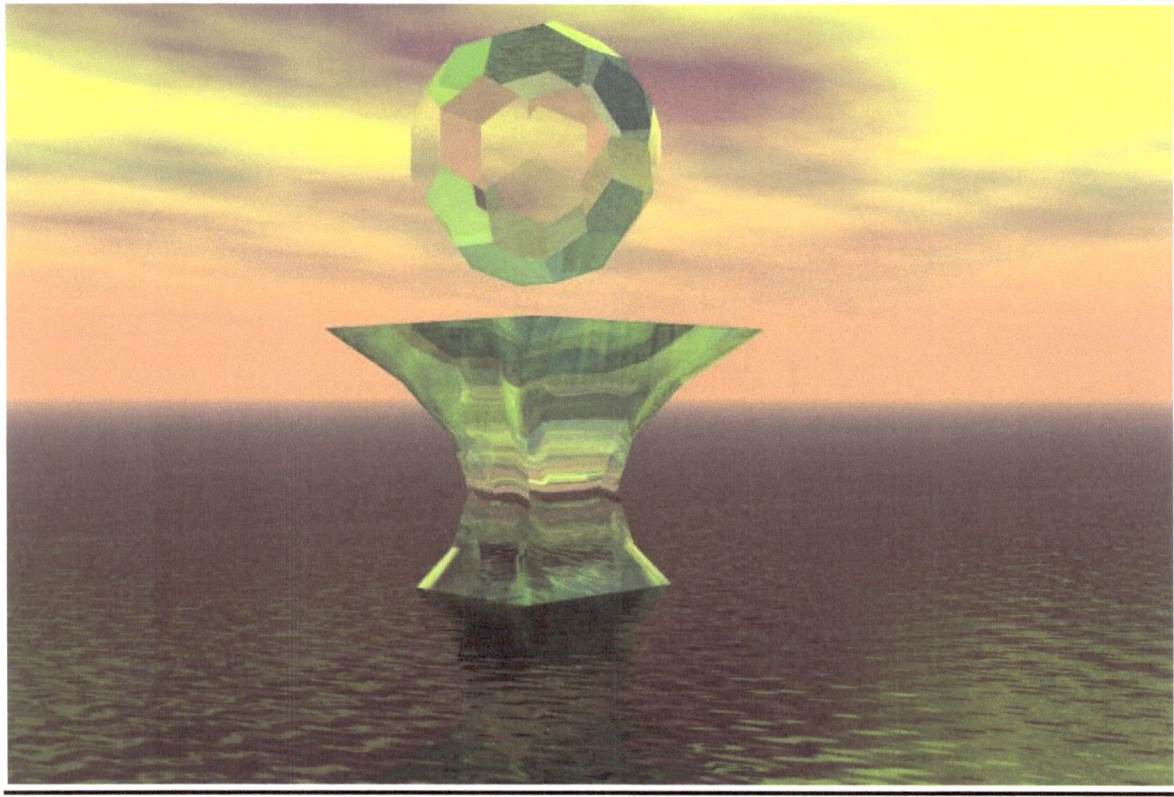

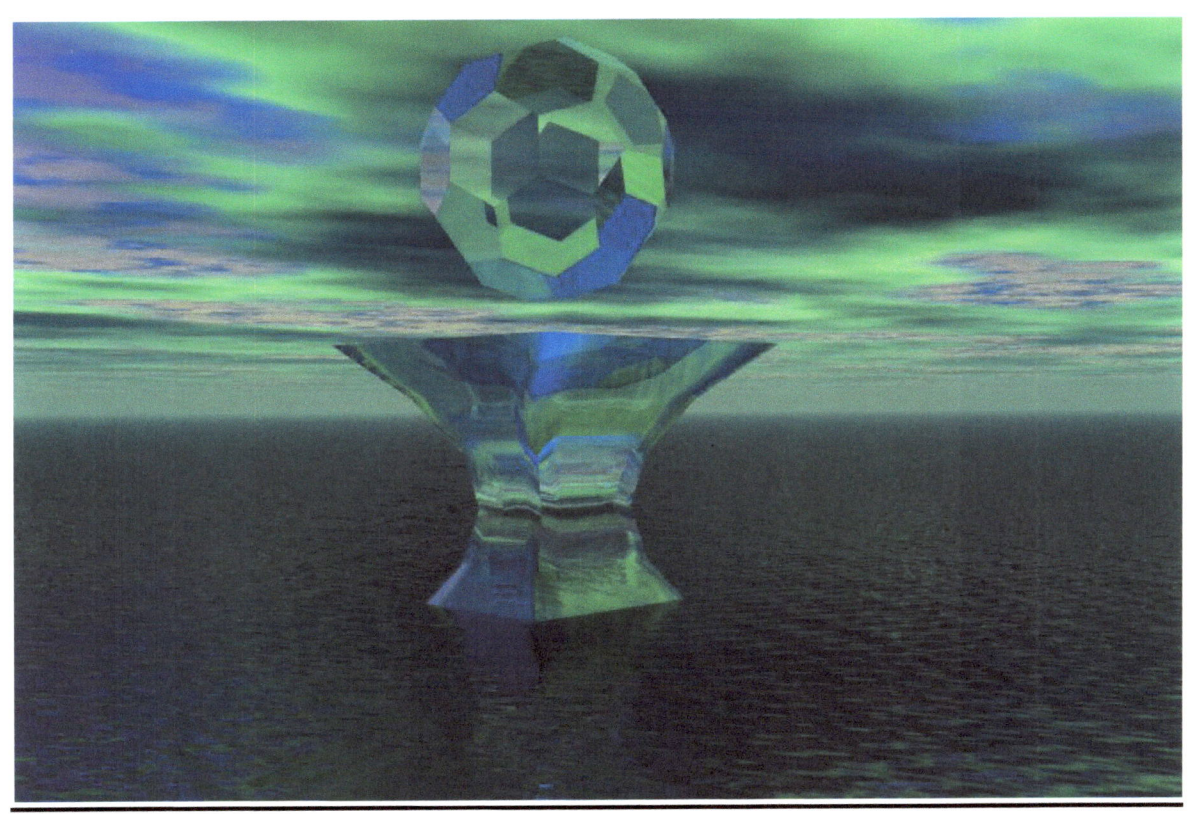

Golden Arch:

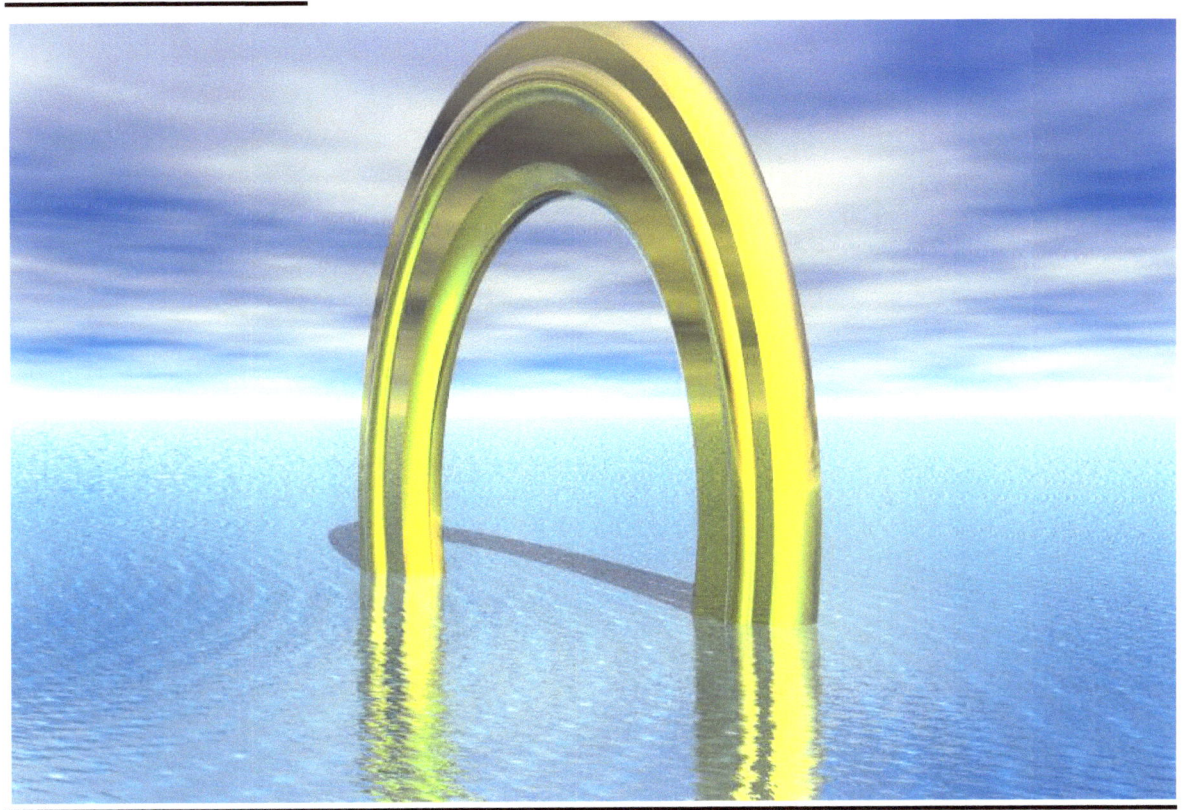

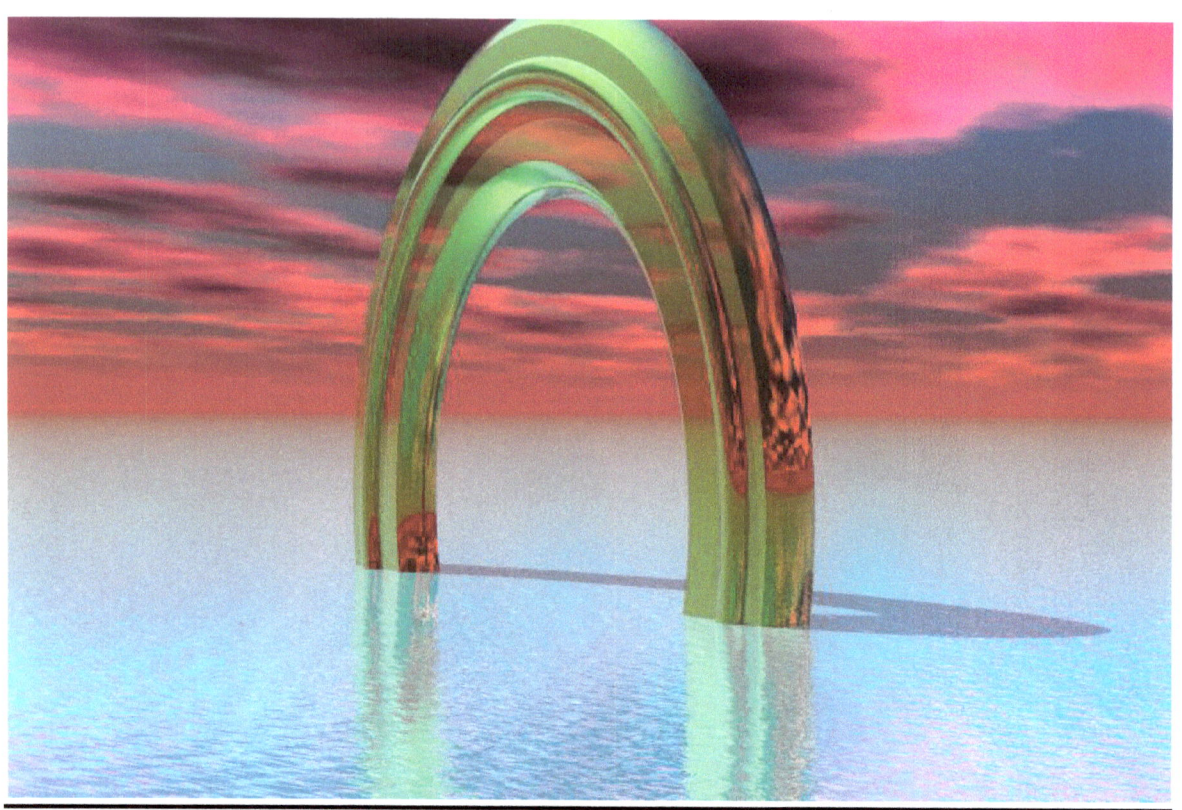
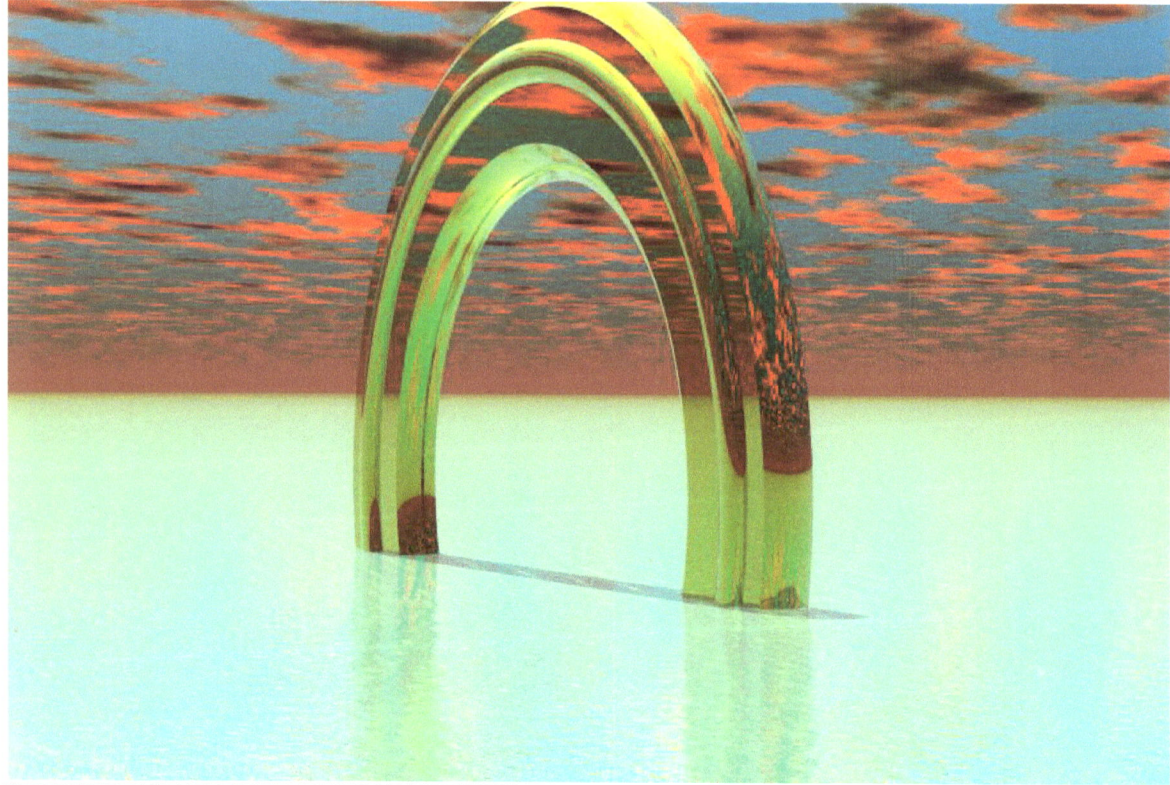

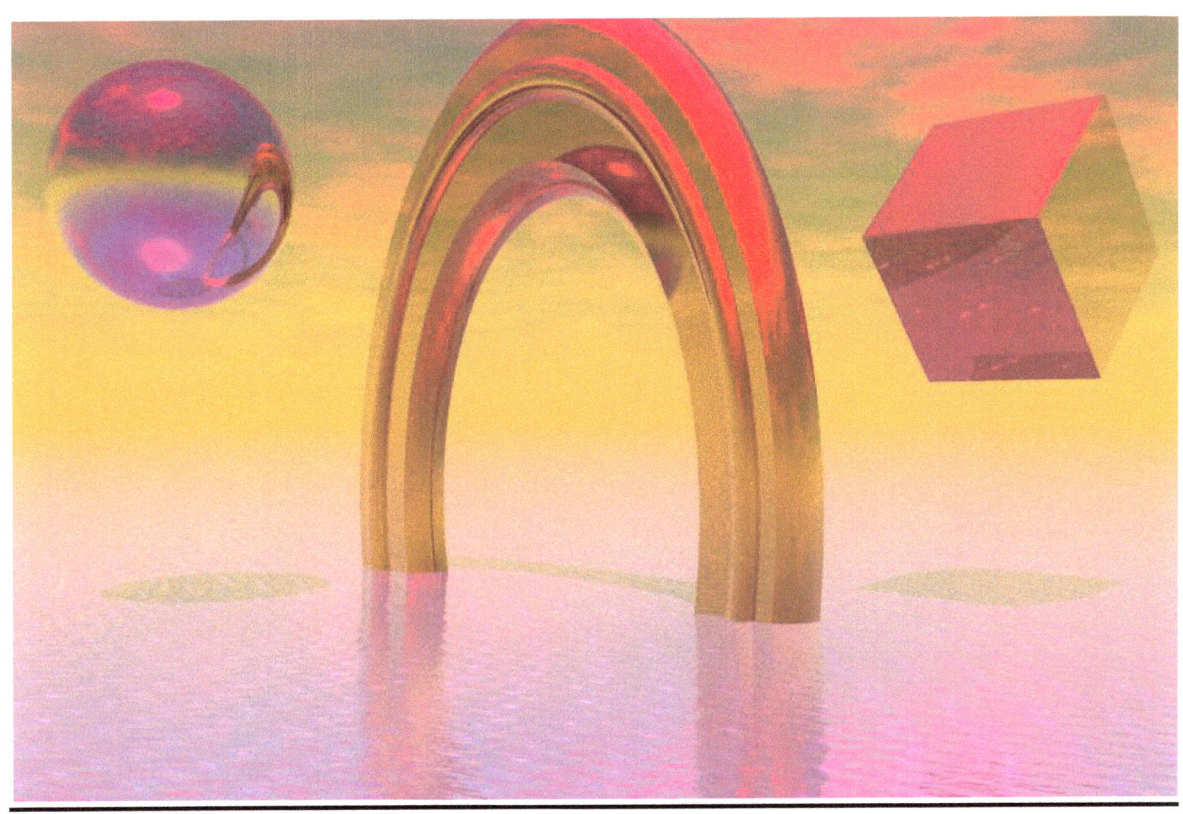

Silver Sphere & Golden Arch:

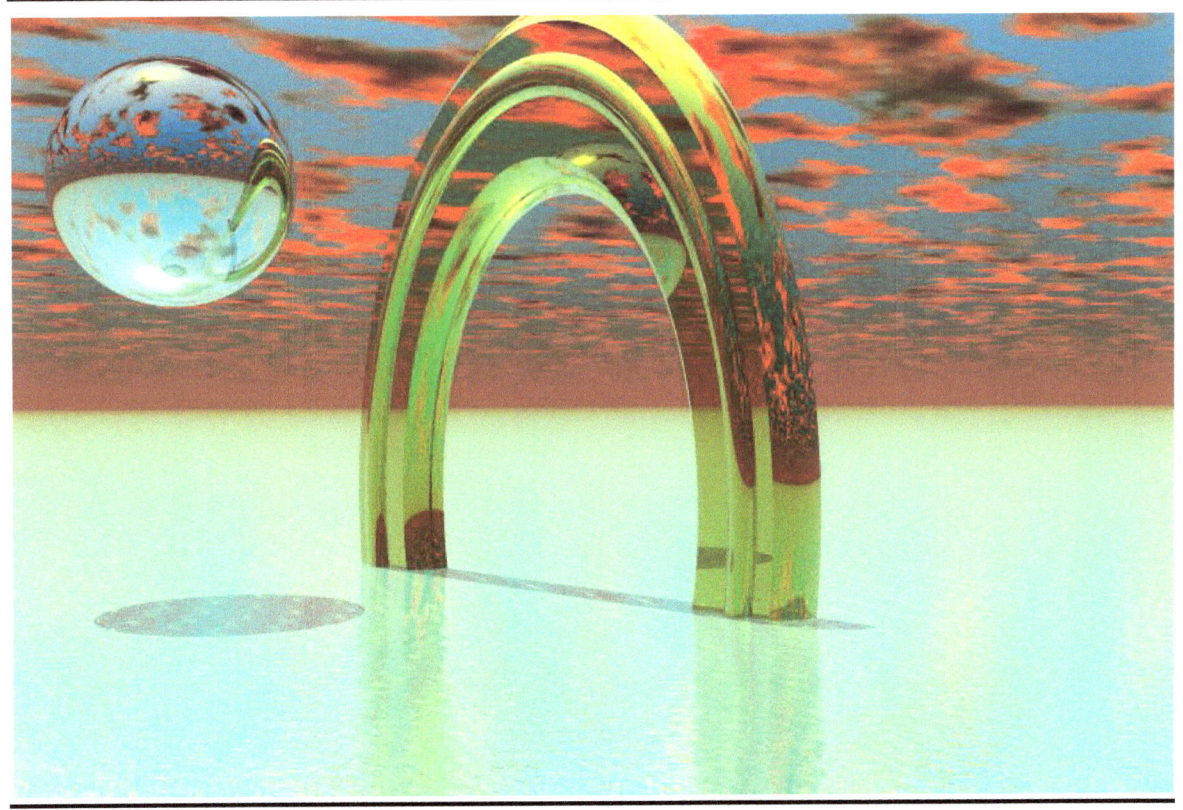

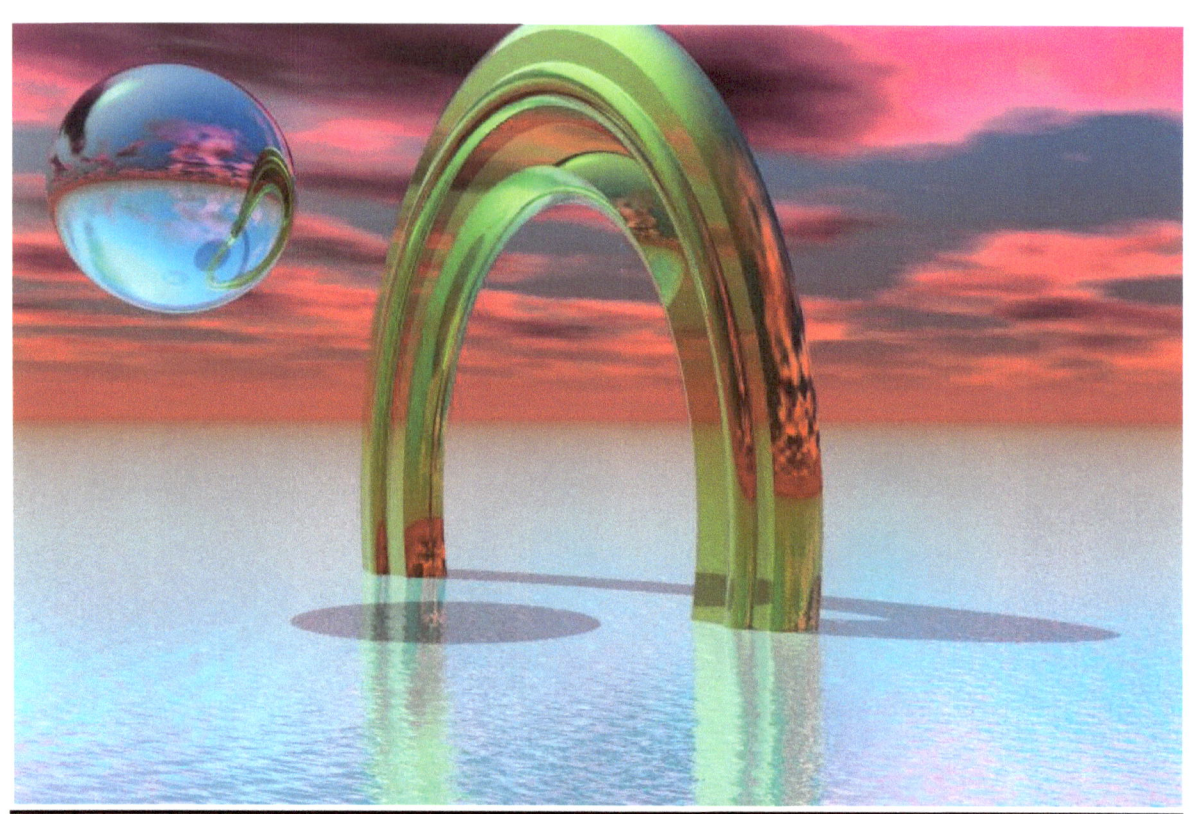
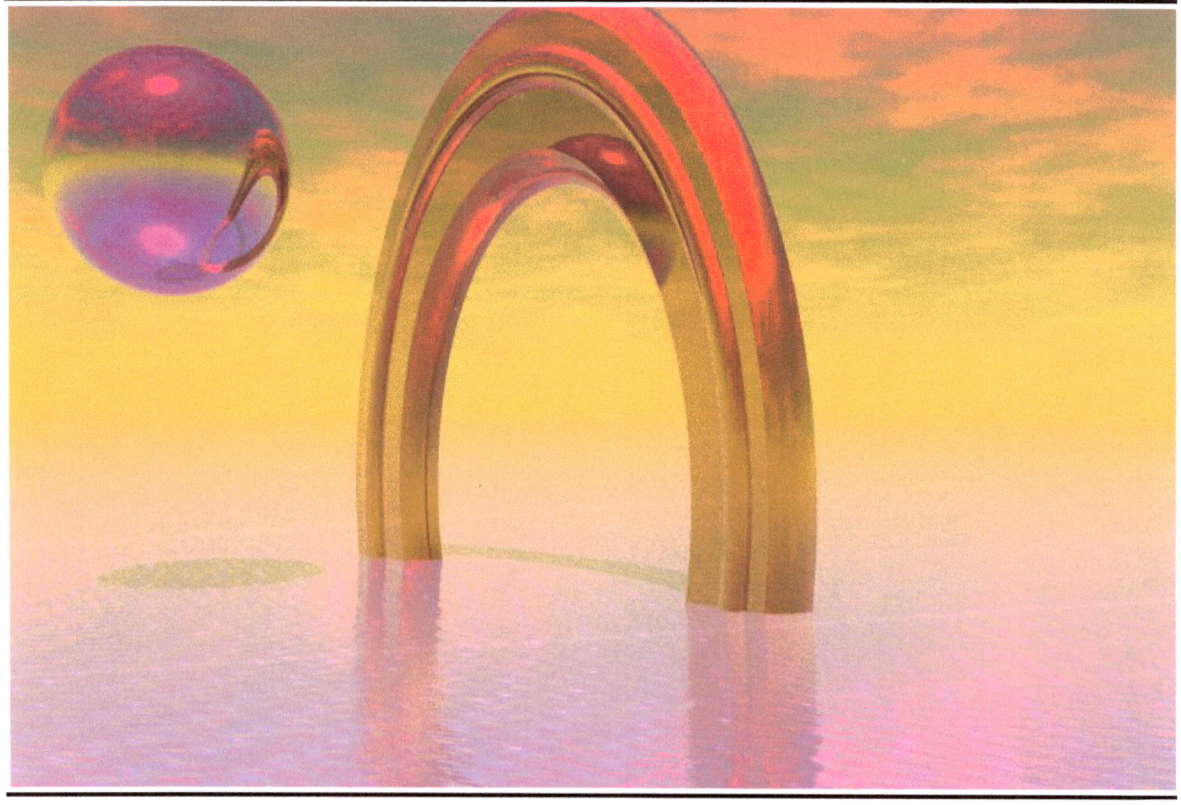

Golden Pyramid & Silver Spheres:

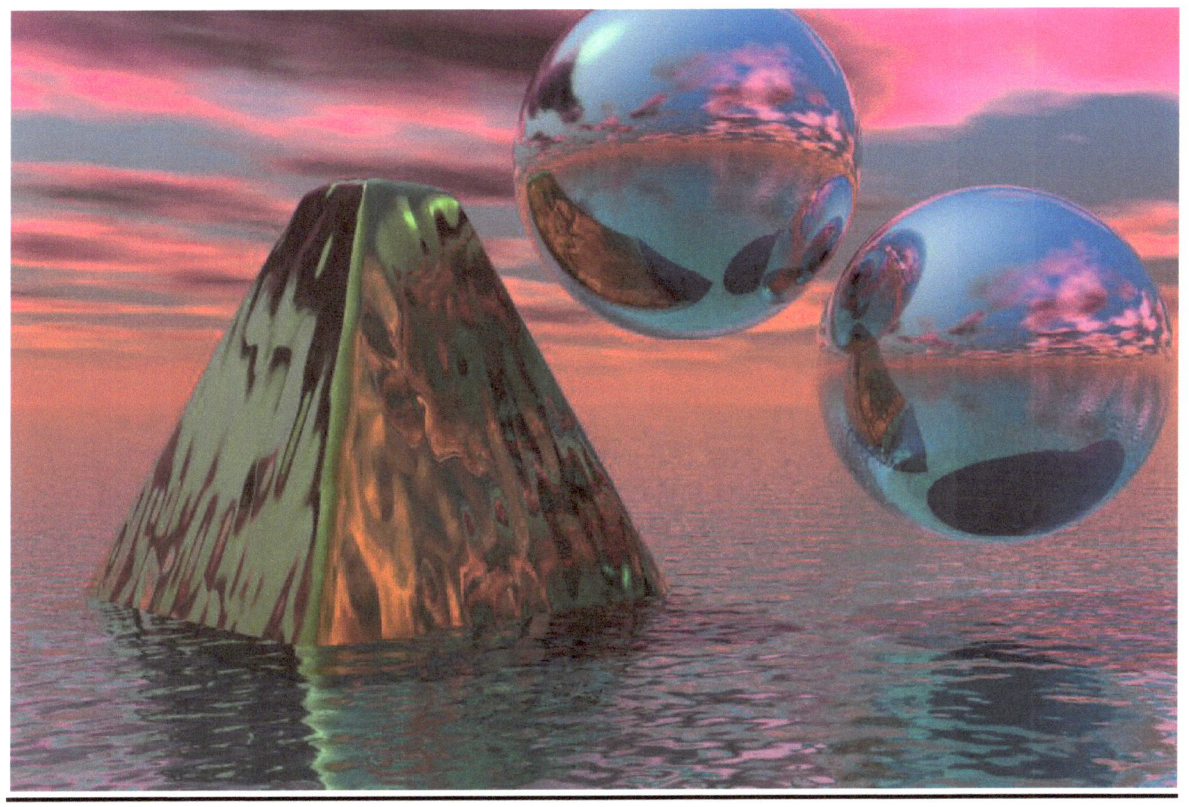

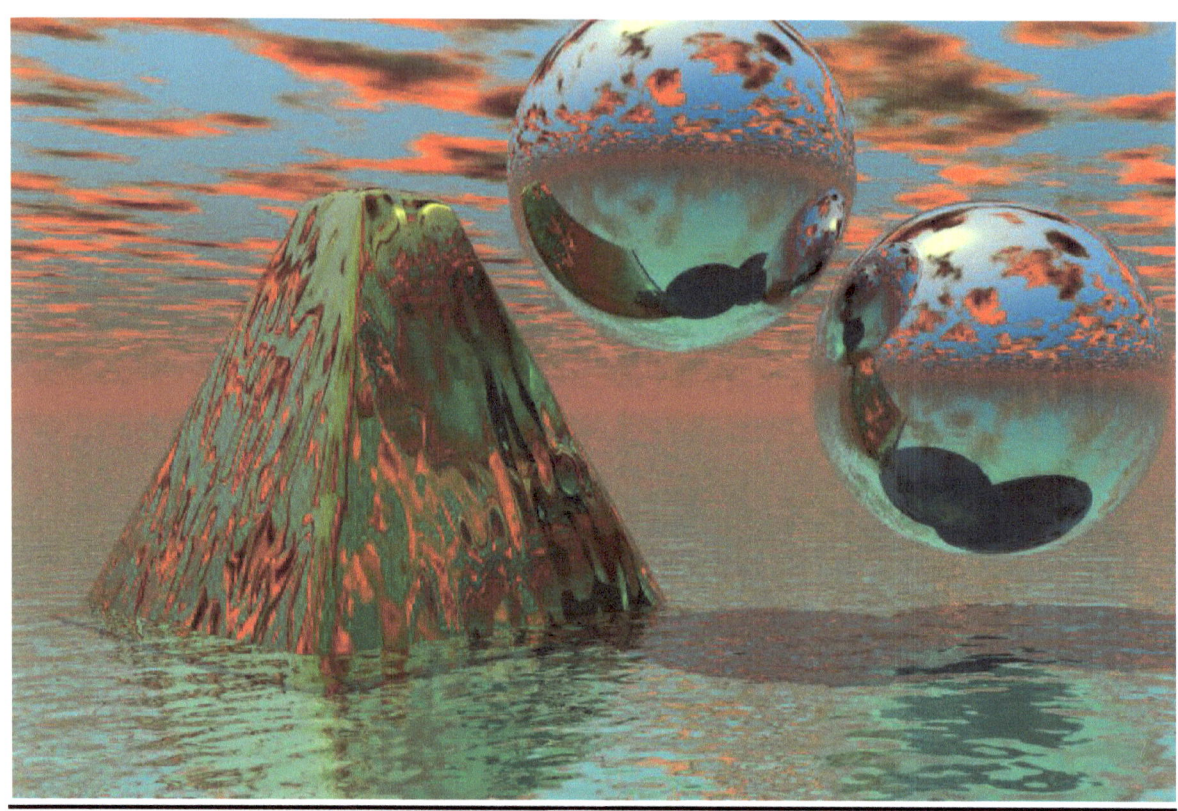
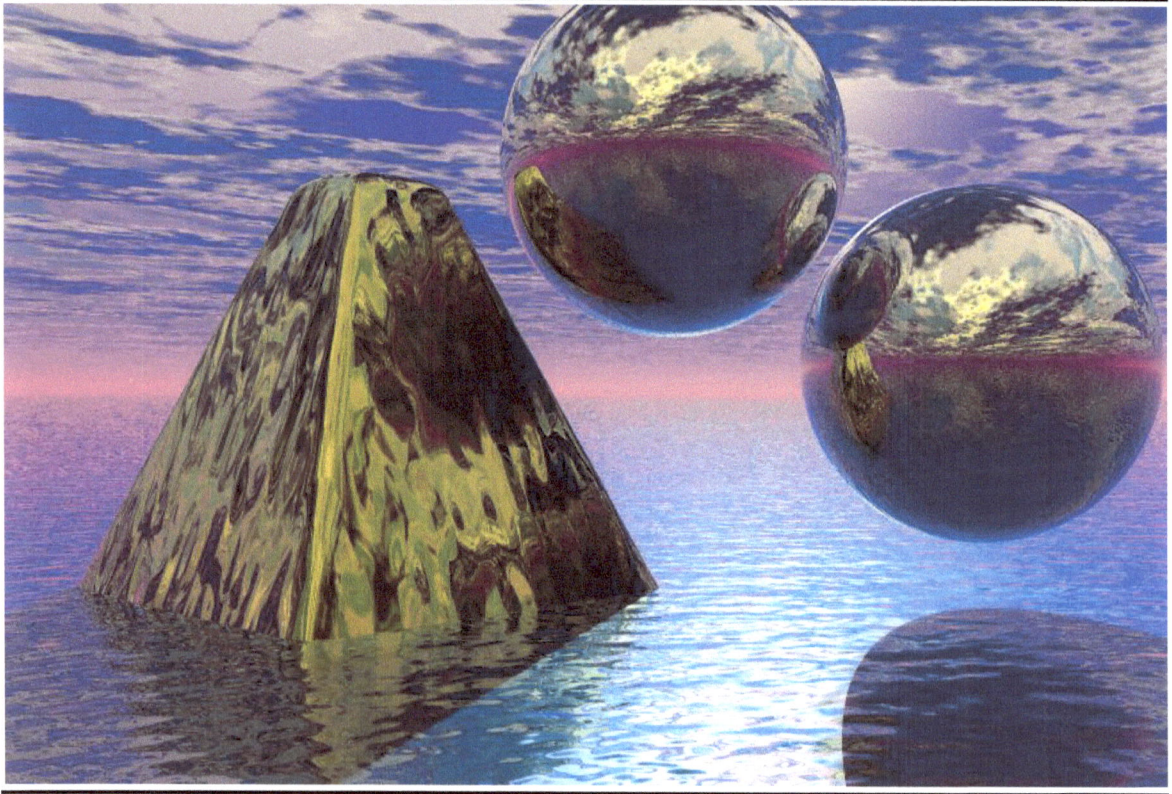

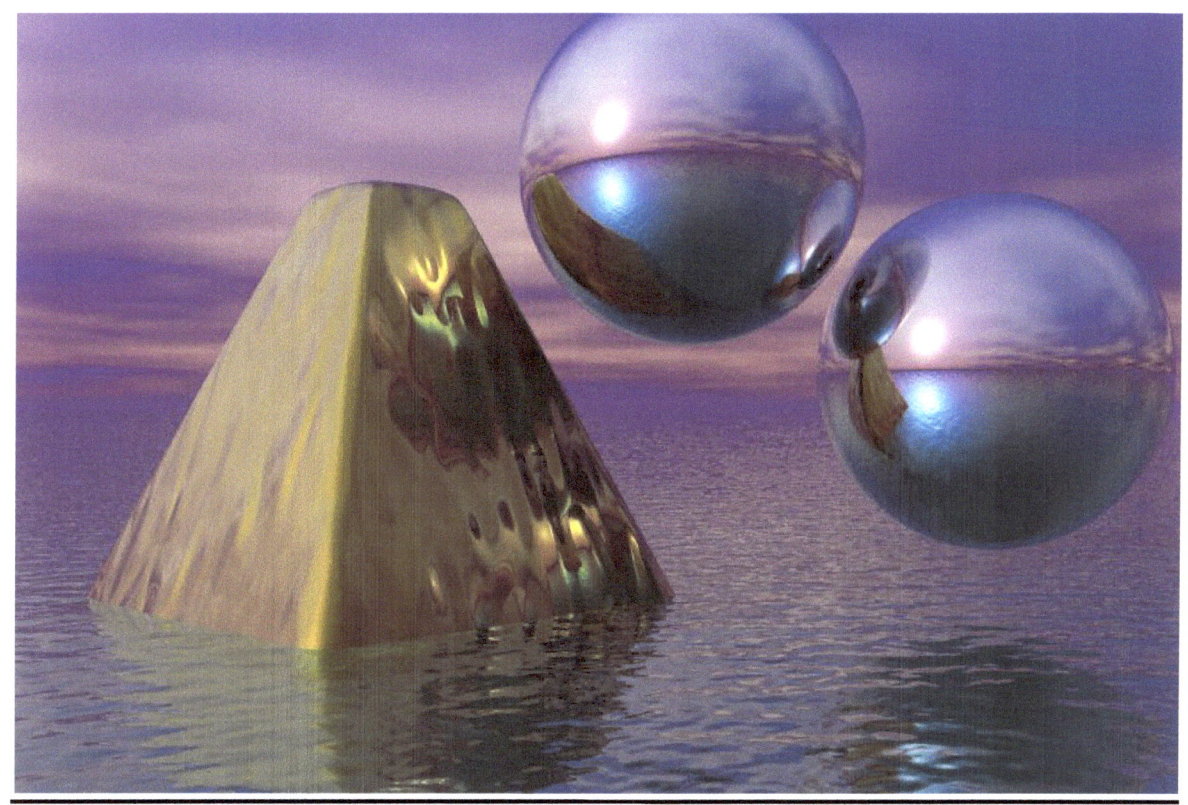
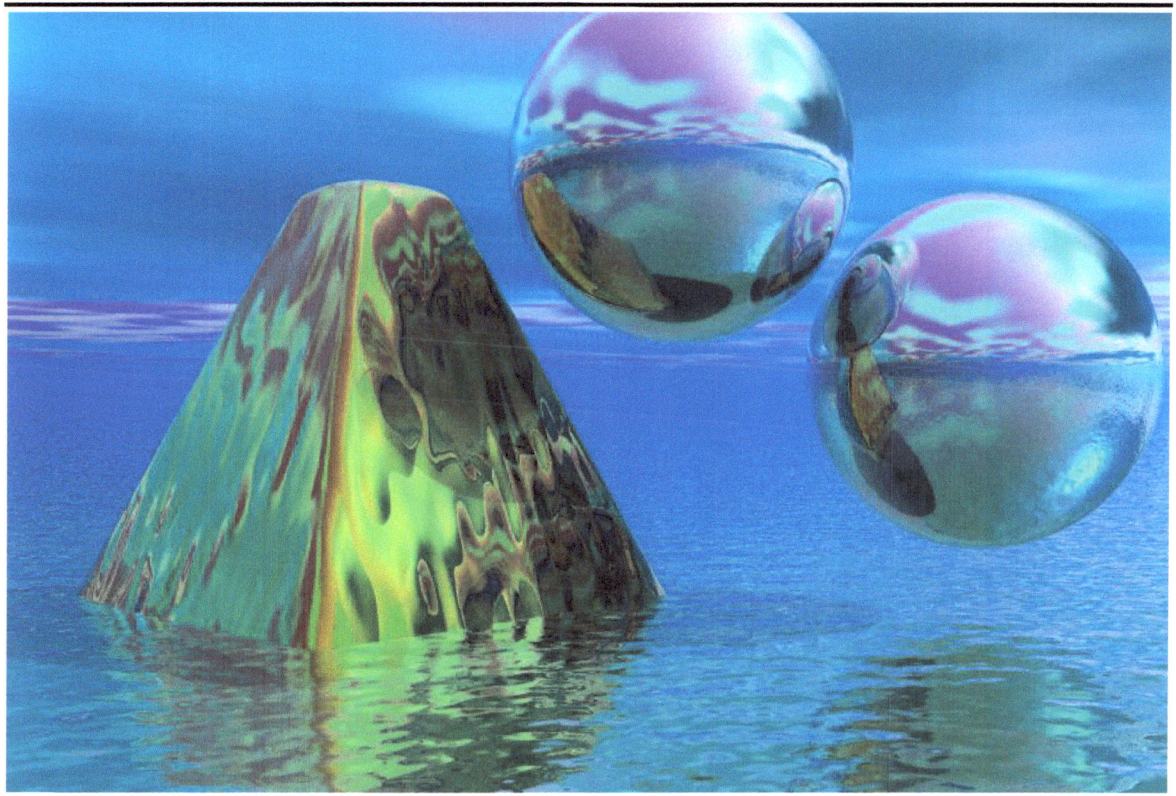

Diamond, Cut Alexandrite Sphere, Emerald:

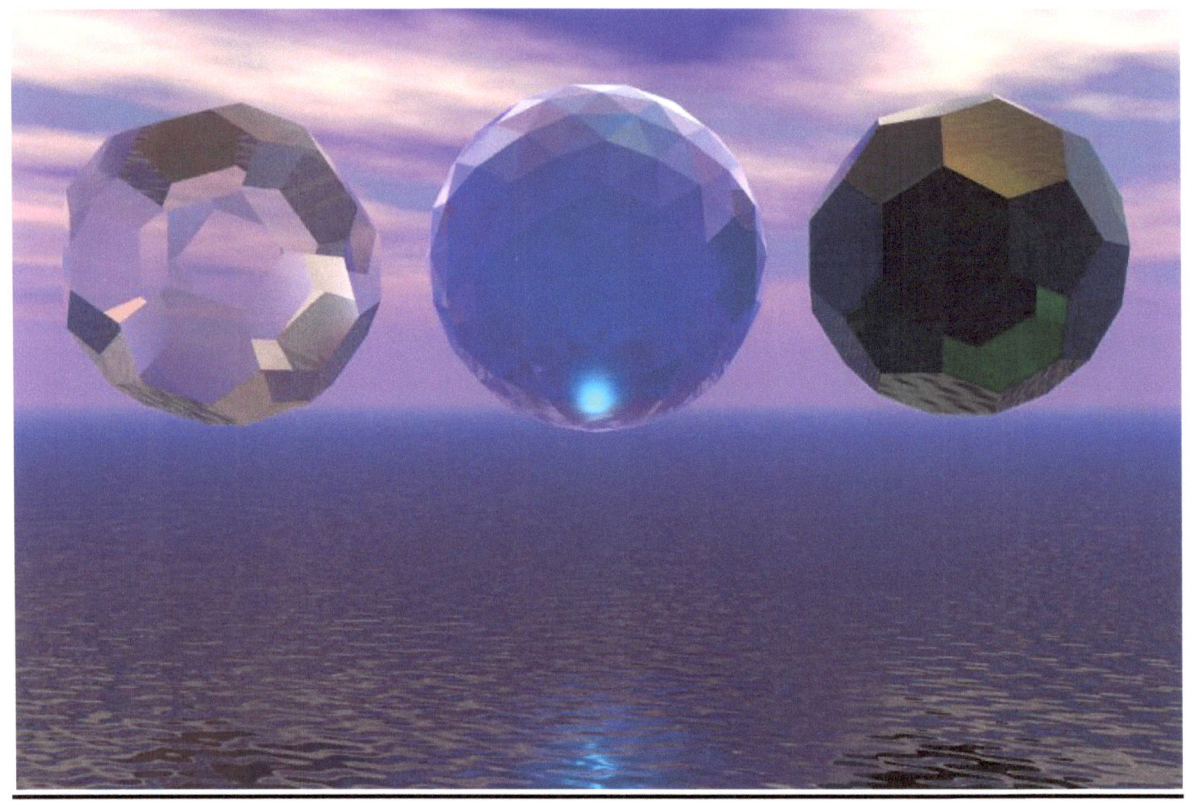

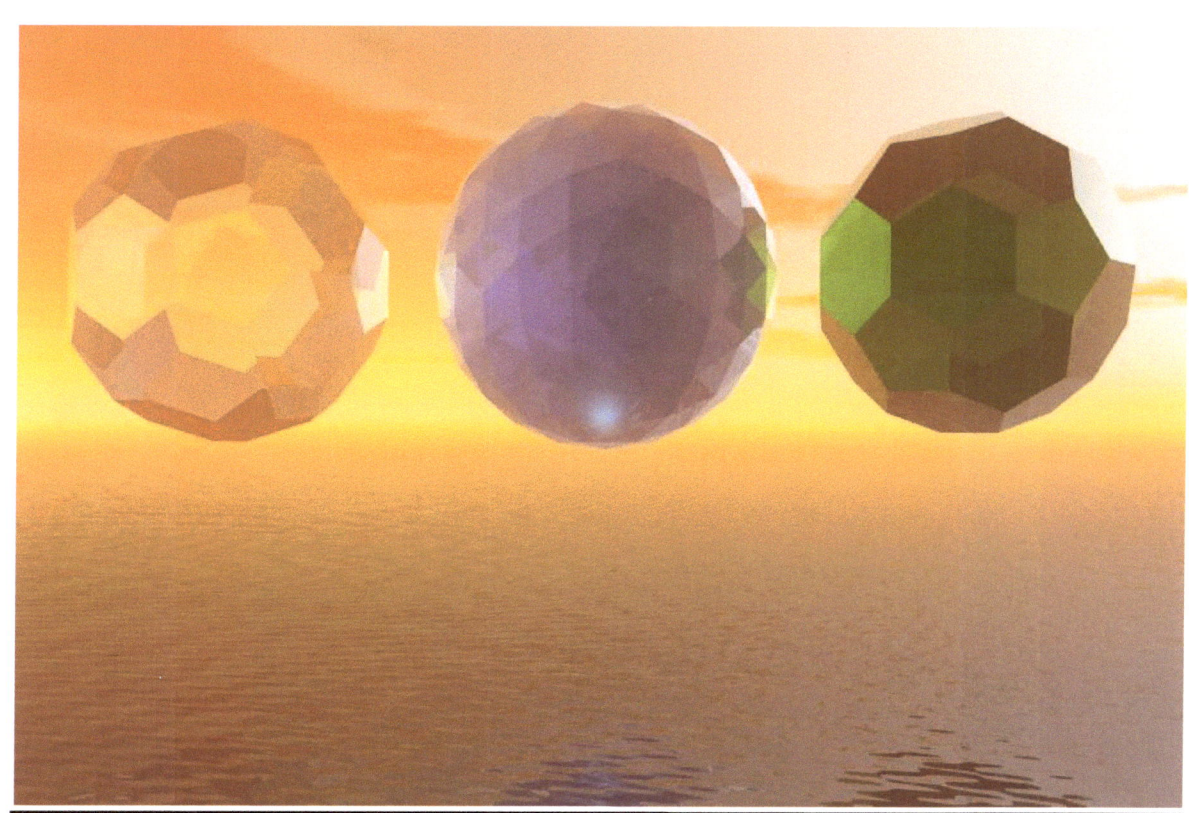

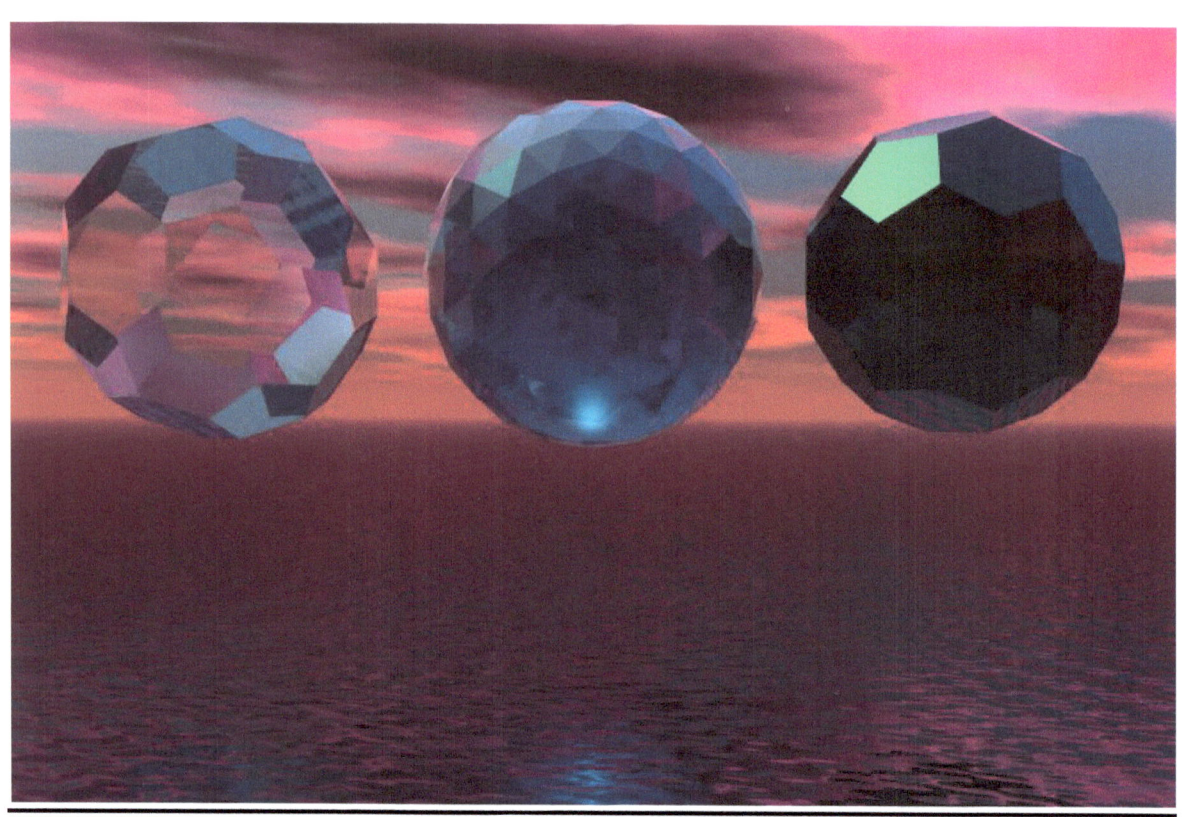
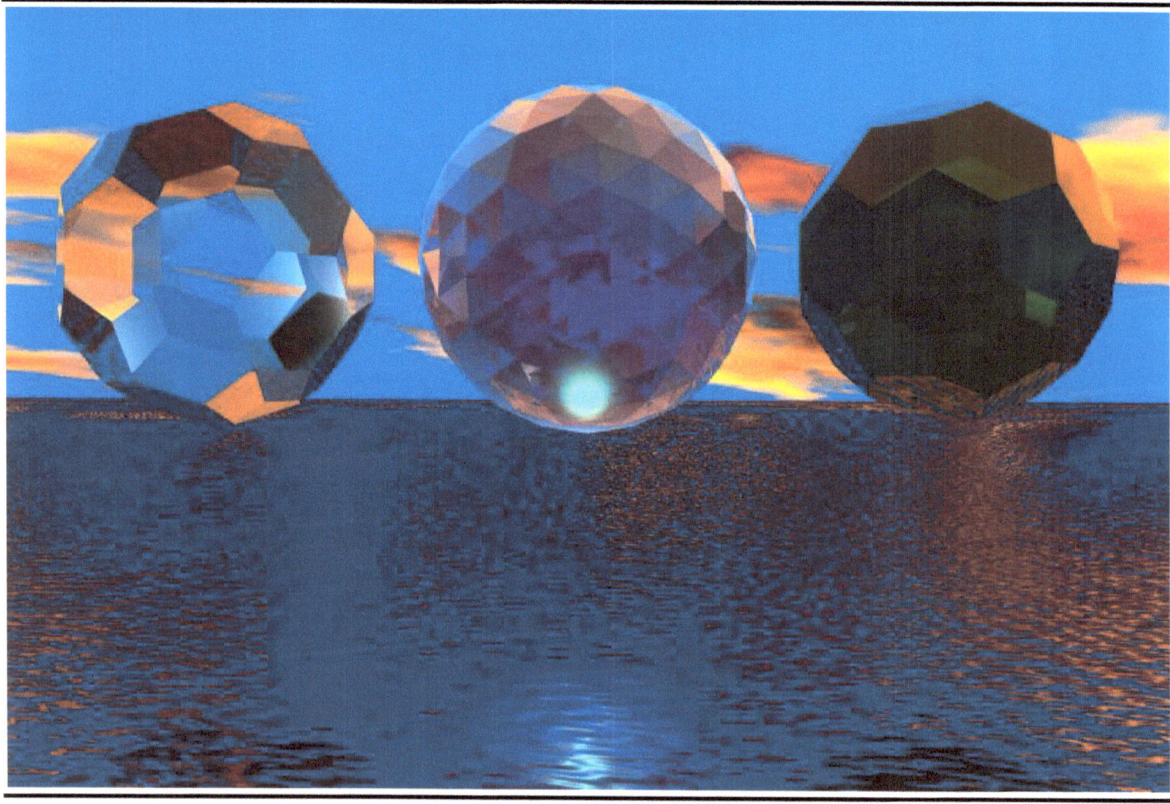

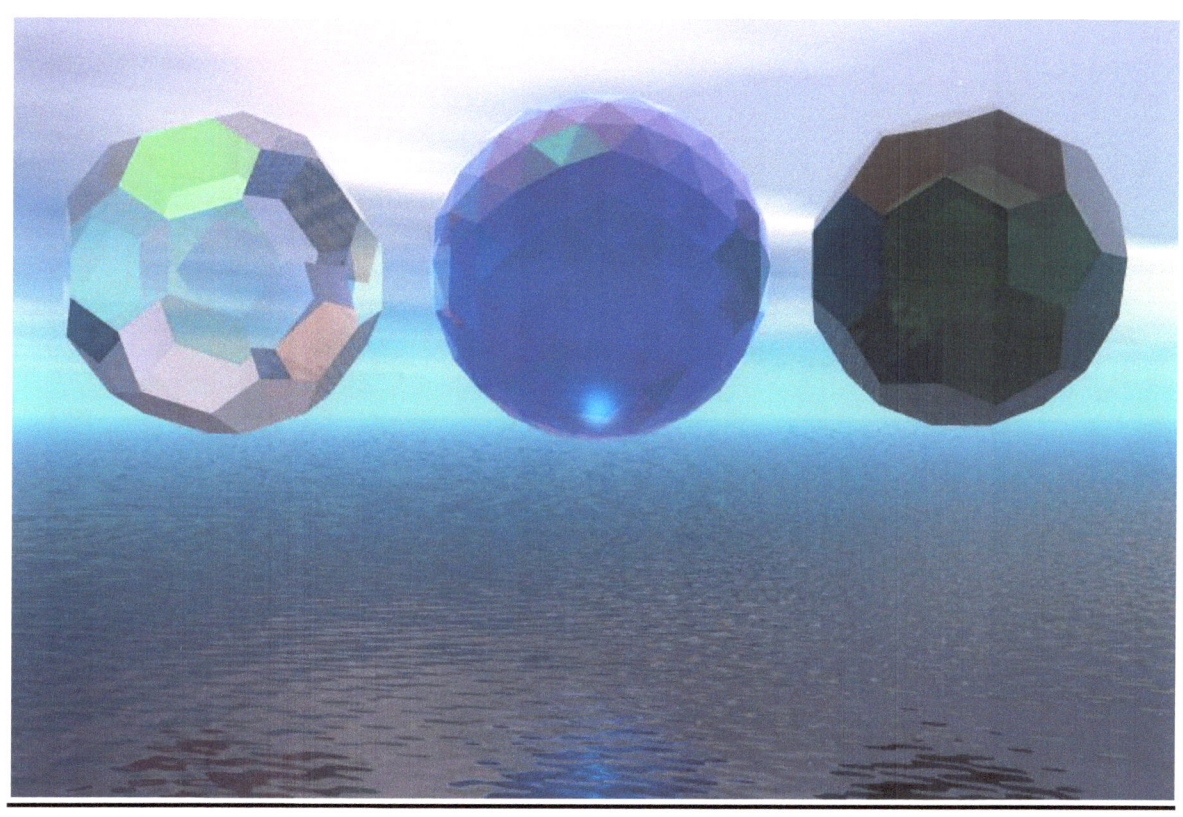
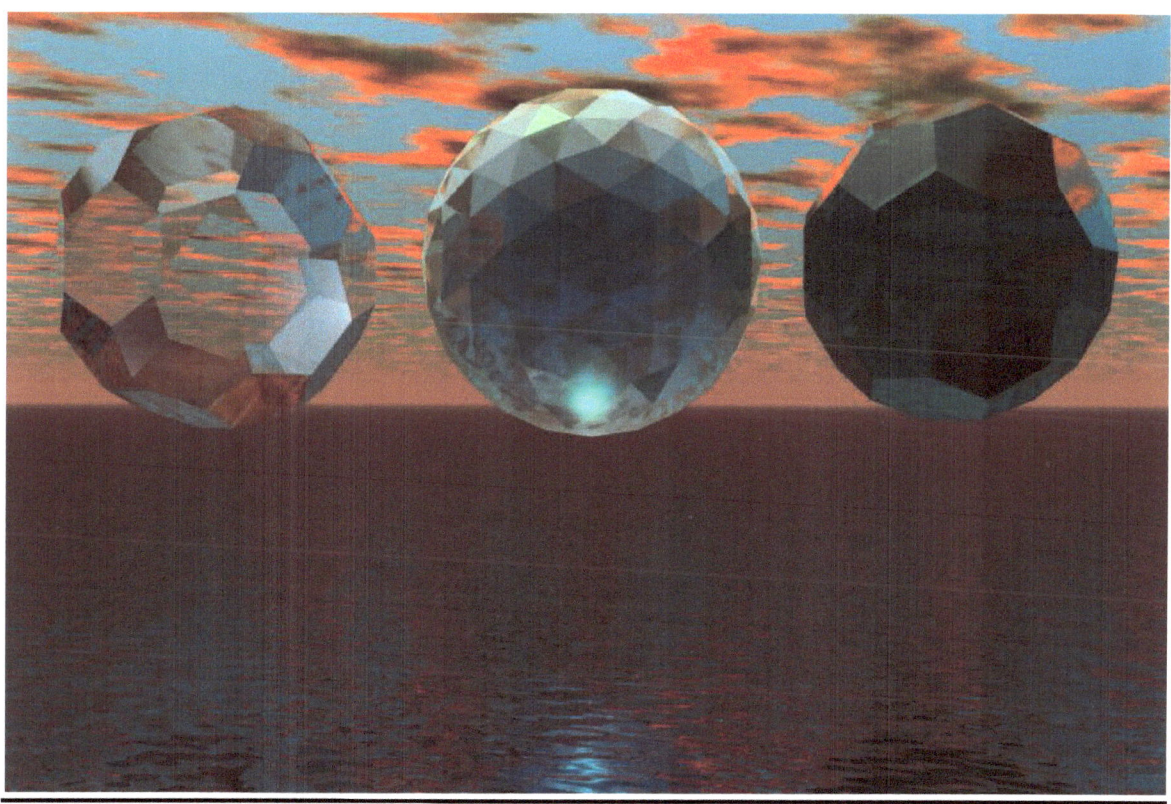

Huge Diamond Sculptures:

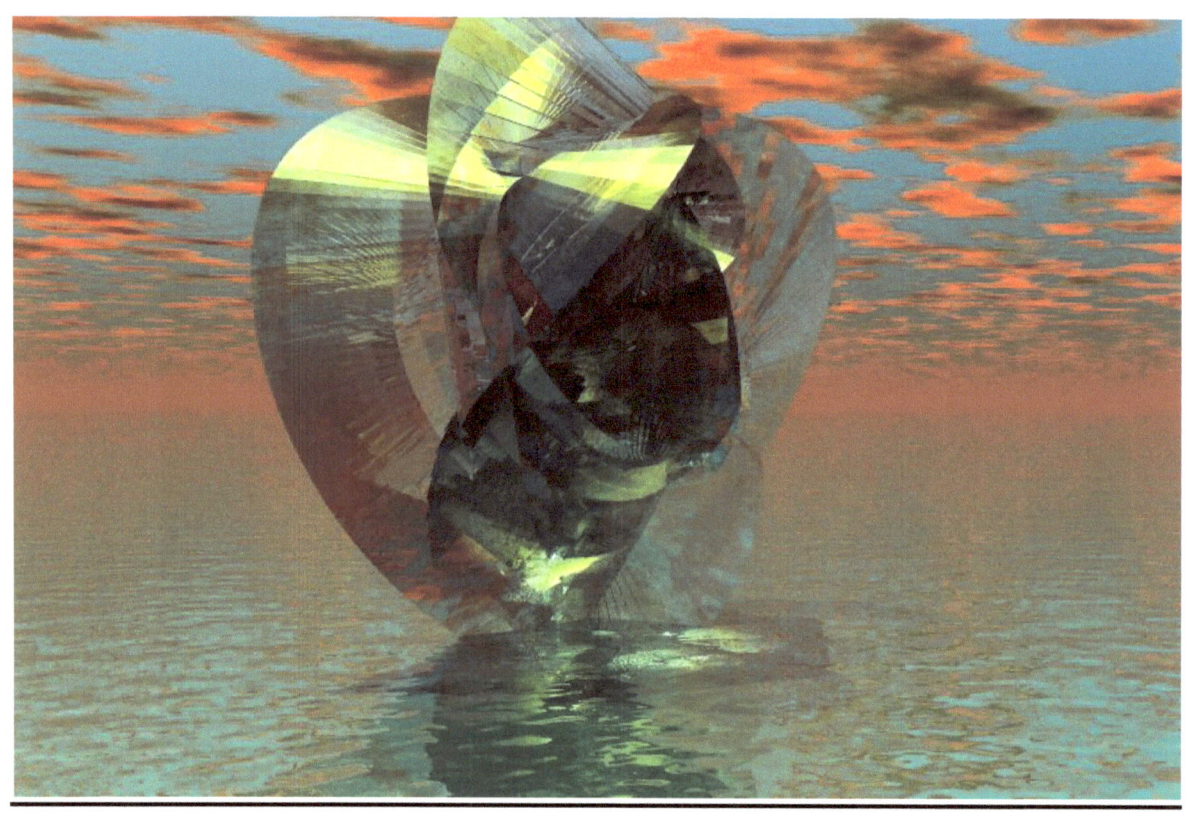

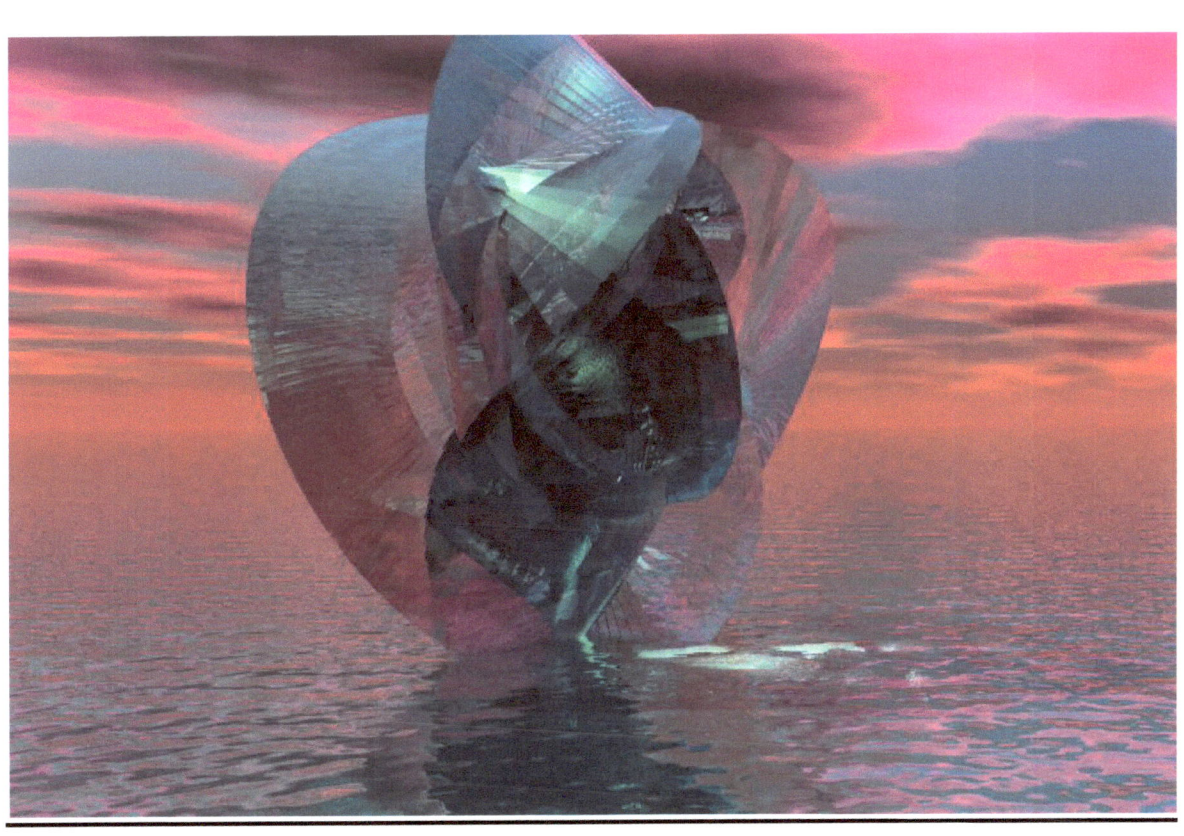

www.ingramcontent.com/pod-product-compliance
Lightning Source LLC
Chambersburg PA
CBHW050907180526
45159CB00007B/2824